P9-BZJ-950

THE COMPLETE BOOK OF
CARICATURE

THE COMPLETE BOOK OF
CARICATURE

BY BOB STAAKE

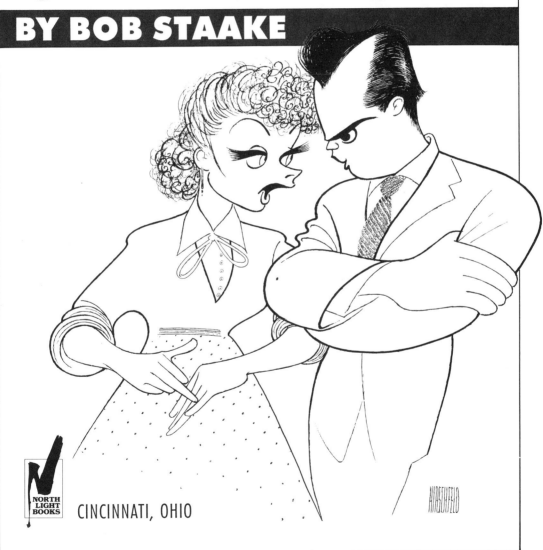

NORTH LIGHT BOOKS

CINCINNATI, OHIO

The Complete Book of Caricature. Copyright © 1991 by Bob Staake. Printed and bound in the United States of America. All rights reserved. No part of this book may be reproduced in any form or by any electronic or mechanical means including information storage and retrieval systems without permission in writing from the publisher, except by a reviewer, who may quote brief passages in a review. Published by North Light Books, an imprint of F&W Publications, Inc., 1507 Dana Avenue, Cincinnati, Ohio 45207. First edition.

95 94 93 92 91 5 4 3 2

Library of Congress Cataloging in Publication Data

Staake, Bob
 The complete book of caricature / Bob Staake.
 p. cm.
 Includes bibliographical references and index.
 ISBN 0-89134-367-9
 1. Caricature. 2. Caricature—Marketing. I. Title.
NC1320.S75 1991 90-22614
741.5—dc20 CIP

Edited by Susan Conner
Designed by Cathleen Norz and Bob Staake
Cover illustrations by Robert Risko (Stevie Wonder); Sam Norkin (Katharine Hepburn); Bill Plympton (Woody Allen).

Pages 130-131 constitute an extension of this copyright page.

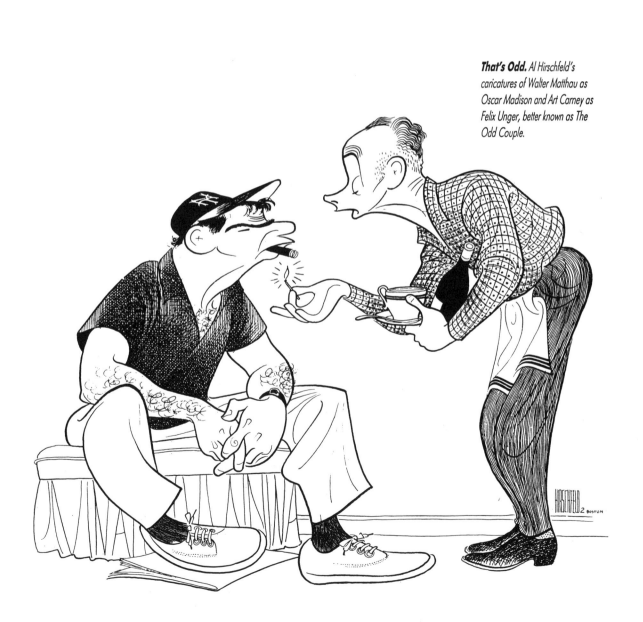

That's Odd. *Al Hirschfeld's caricatures of Walter Matthau as Oscar Madison and Art Carney as Felix Unger, better known as The Odd Couple.*

D E D I C A T I O N

To

Paulette and Ryan

for putting up with the

long hours and

long noses

Give Her a Flattop and It's Grace Jones. *But actually, it's a caricature of Dionne "Do You Know The Way To San Jose?" Warwick by Rudy Cristiano.*

A C K N O W L E D G M E N T S

The author wishes to thank the following individuals and institutions for their valuable assistance in this book project:

David Leopold and Margo Feiden of The Margo Feiden Galleries; Will Vinton Productions; King Features Syndicate; Mike Peters; Rich Balducci; Jack Dickason; Library of Congress; National Museum of American Art; Mary Voith; Don Bajus; Mike Jones; Robert Lescher; Fred Voss of the National Portrait Gallery; Kathleen Gee of the Harry Ransom Humanities Research Center at the University of Texas at Austin; Susan Conner; David Lewis; Bob Shay; the Los Angeles Times Syndicate; the Smithsonian Institution; Milton Glaser; the American Association of Editorial Cartoonists; Steven Heller; Wendy Wick Reaves; Ellen Fair of E*squire* magazine; Miriam Stewart of the Fogg Art Museum at Harvard University; William Gaines; MAD magazine; Carol Buchanan; and Schlitzey "The Wonder Pig."

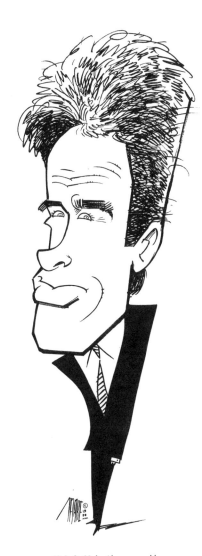

He's So Vain. *I have no problem with the fact that my caricature of Warren Beatty exists not as an overt editorial statement, but simply as an illustration option. This caricature illustrated an article about the actor/director. Because the article was humorous in tone, it was felt that a caricature would best complement it.*

C O N T E N T S

INTRODUCTION

1

THE ROLE OF CARICATURE 2

Do your caricatures make a political statement or
do they entertain?

2

CARICATURE APPLIED 22

Learn how to begin selling your work at parties, then branch
out to other markets.

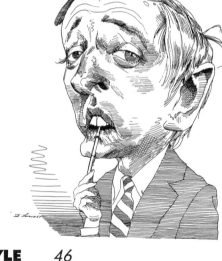

3

CARICATURE STYLE 46

The best in the business show you how to develop style.

4

THE CARICATURIST AS "FACIAL DETECTIVE" 70

Discover how you can capture personality by spotting the right features and mannerisms.

5

CARICATURE REFERENCE *92*

Learn how to work from photos, TV and video, real life and from memory.

ARTISTS' PROFILES *112*

INTRODUCTION

I learned about the power of caricature at a young age.

As high school students in Los Angeles, it was essential that we have at least one year of math before heading out into the real world. Being a horrible procrastinator and mathematician, I waited until my senior year to succumb to the Board of Education's mandate that I be taught to add, subtract and even multiply.

As I scanned the listings of math courses — Algebra was out, ditto Geometry and Calculus — I stumbled on a listing for Business Math. Easy enough, I thought. A little addition, a little subtraction, a little understanding of what it means to be "in the red." Better yet, the class was taught by the cross country coach who seemed to be a decent enough guy.

But within the first two weeks of class, it became immediately apparent to me and my math "coach" that I wasn't understanding questions dealing with dollars and cents. We had a problem. After all, I had to graduate, and it would look pretty embarrassing if the student who was voted "Most Likely to Succeed" was conspicuously absent from commencement ceremonies. Being a good coach, my math teacher knew when to throw in the towel.

Rather than leading me through the rigors of long division, my math mentor made me a business proposition. What would be lovelier, he

thought, than to unveil caricatures of each member of the cross country team at the annual banquet? All I would have to do is *draw* them in exchange for a compensatory passing grade in Business Math. Dishonest, immoral and unethical, it was nonetheless the first time that my talent as a caricaturist paid off.

I find caricature to be the most personally rewarding of all the cartoon arts. Nothing can compare to the exhilaration I feel when I graphically lampoon a subject with proficient pen. However, it is difficult to teach someone else this enigmatic art so that he will be able to experience the same exhilaration.

To be honest, I don't think caricature can be taught. You'll rarely find a course in caricature at a university or even a major art school. The only way for aspiring caricaturists to nurture their talent is by emulating and mimicking the great caricaturists like Al Hirschfeld, David Levine, Mort Drucker, Miguel Covarrubias, and Ed Sorel. The masters themselves acknowledge that they were influenced in their formative years by the great caricaturists of the day. Caricature, like a good chicken gumbo recipe, is passed down through the tribe from generation to generation.

While I have set forth my own idea of how and why caricature should exist, I felt it of paramount importance to interview other caricaturists to get *their* insights into

this enigmatic art form. Without the magnanimous support of these renowned caricaturists, this book simply would not have been possible. If this book inspires, if it influences, if it reveals some of the "secrets" of caricature, then this book has fulfilled its noble purpose.

And best of all, there is no math.

Bob Staake

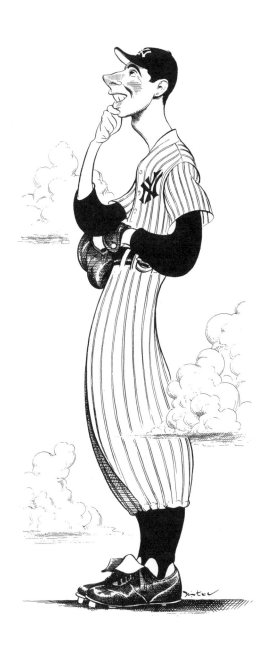

Head and Body in the Clouds.
Michael Witte's inspired caricature of Joe DiMaggio. Witte says, "I've always considered myself more of a humorous illustrator than a social satirist."

1

Out, Damned Spot! *A frequent victim of David Levine's acerbic pen, Richard Nixon is caricatured rubbing himself out. "Nixon," says Levine, "was such a delight for our pens."*

THE ROLE OF CARICATURE

While caricature has been romanticized as a powerful art form capable of effecting change, exposing corruption, and even toppling governments, rarely does it accomplish such altruistic triumphs. If it did, more caricaturists would be locked up in dank prisons. Prisons may be overcrowded, but they do not contain an overpopulation of insubordinate doodlers.

Nevertheless, many politically oriented caricaturists attack with pen and paper as if such honorable results were at least possible, if not probable. For these individuals, caricature is a mission—and a caricature devoid of passion, editorialized opinion or purpose would be simply unthinkable.

On the other hand, there are caricaturists who resign themselves to the role of entertainer. Instead of skewering politicians and venting their ideological beliefs on a blank piece of paper, these caricaturists regale us with astute observational depictions of their subjects. Their likenesses are rife with design as well as technical and aesthetic appeal, yet they refrain from overt editorializing.

Caricature itself has no set role. Rather, the individual caricaturist determines his individual role, purpose or reason for doodling.

ROLE, ROLE, ROLE YOUR BOAT

"At the moment," says Steven Heller, art director of the *New York Times*, "I don't see much of a role for the caricaturist beyond entertainer. Today there just are very few outlets for political caricature, where in the late nineteenth century you had *Puck* and *Judge* magazines and caricaturists who were partisan politicians or concerned with humankind or just curmudgeons. They thought that their art could effect some sort of change, and Thomas Nast proved that it could be done."

Back Stabber. *A promotional piece designed to hype the caricature talents of Kevin "KAL" Kallaugher of the Baltimore Sun shows the editorial cartoonist himself hefting a dangerous pen at a variety of world figures.*

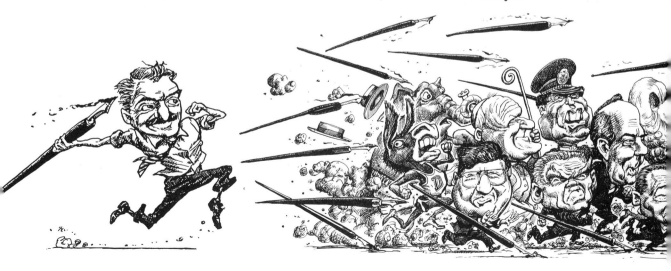

My Dinner with Jesse. *Ori Hofmekler alludes to Norman Rockwell's infamous painting, "Freedom from Want," by caricaturing (from lower left around table) Jesus Christ, Muammar al-Qadhafi, Louis Farrakhan, Yasir Arafat, Jesse Jackson, Jacqueline Jackson, Fidel Castro, Ayatollah Khomeini, Hafez al-Assad. The painting was published by Penthouse magazine.*

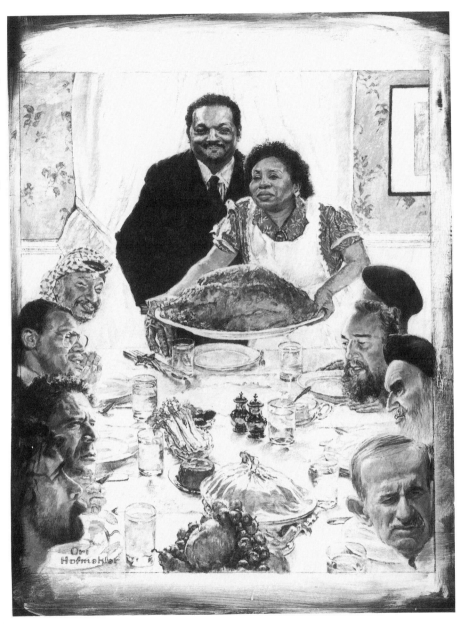

Heller attributes the declining persuasive power of the modern-day caricature to one technological communications force—television. Indeed, one of the reasons for Thomas Nast's uncommon influence was the fact that during his era, photographic images couldn't even be reproduced. Nast, therefore, was afforded a massive audience eager for any and all imagery, including his ink-crosshatched cartoons. Preindustrial times were very good for artists like Nast.

"I'm on both sides of the fence here," Heller admits. "I am a real strong supporter of political caricature, but I just don't think it does anything. I'd like to see it continually used, but that doesn't mean it's going to have the same impact it once had fifty, seventy-five or one hundred years ago."

Instead, Heller sees the contemporary caricature as but an illustration option. "Today," Heller continues, "Al Hirschfeld is a remarkable caricaturist and stylist, but his images do little else than embellish a page and offer us a creative alternative to staid photography. And when David Levine draws a caricature for the *New York Times Review of Books*, he's just giving us an alternative view of an individual. It's entertainment.

"The best thing a caricaturist can do in a negative sense," says Heller, "is provide an image of somebody who you are hoping to defame, and that image then becomes truth for you. However, caricature does not have to be an [offensive] weapon. Hirschfeld has proved that."

MAKING A STATEMENT

Perhaps best known for illustrating Dr. Hunter S. Thompson's rambling, "gonzo" journalistic articles and books, British caricaturist Ralph Steadman has a proclivity for attacking his subjects with vicious caricatures that lack any iota of subtlety. Politicians stand a better chance against a rabid pitbull than they do against Steadman's vitriolic pen. Steadman's caricatures are the byproduct of his frustration. "There is despair in me," he says, "of the human condition. You just don't compromise if you are going to draw about it. Caricature isn't a business, it's a cause. It's the next best thing to shooting somebody."

Yet Steadman concedes that caricature (more appropriately his) almost always falls short of effecting real change. "When I first started doing work in America," Steadman says, "I came with the idea that I was going to change things. But it's gone from bad to worse, so obviously I haven't done a good job. I thought that by showing what was wrong and what was right, I could change society and make people nicer. But they haven't—they've got worse."

In recent years, Steadman's dismay has turned to disillusionment. He has even gone so far as to urge cartoonists around the world to join him in his decision to stop caricaturing politicians altogether. "I've decided to never again draw another politician," Steadman declares, "and I want cartoonists all over the world to join me in ignoring politicians. Do cartoons about is-

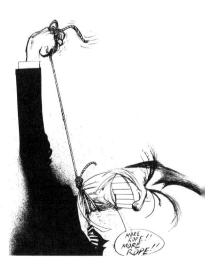

The Last Round-Up. *Ralph Steadman caricatures Ronald Reagan at the end of his rope. "Caricature," says Steadman, "is the next best thing to shooting somebody."*

sues, but avoid drawing politicians—when you do, it's like voting for them. Cartoonists have to stop paying lip service to these politicians. The more vicious we become [with our caricatures], the more they enjoy it. When we caricature them, we acknowledge their power.''

Although Steadman may decide to halt his rendering of politicos, it is doubtful that other cartoonists will jump on the bandwagon. Simply stated, politicians are easy targets and will endure as perennial subjects for the caricaturist's poison-tipped pen.

A fellow Brit, cartoonist/sculptor/animator Gerald Scarfe agrees with Steadman that caricature should be used as an offensive weapon. ''I guess like we all do, I have a vicious and angry side,'' Scarfe admits. ''But I'm most angry about the injustices in our society. I choose to attack [through caricature] the politicians and people in power who bring about these [injustices] and perpetrate them on the average man. You may say that my caricatures are 'vicious,' but I'm not advocating viciousness; I'm frightened of it. My caricatures are of my fears.''

However, Scarfe believes he is able to interject healthy doses of humor and satire into his acerbic editorial lashings. ''A lot of times,'' Scarfe points out, ''my caricatures are just a joke, a bit of fun. They're something that makes life a bit easier because they don't take things

Give Me Your Tired, Your Poor, Your Bulging Jugular. *Ronald Reagan is caricatured by Ralph Steadman preparing to dig his canines into Liberty's neck. Since drawing this caricature, Steadman says he has "decided to never draw another politician. When you draw them, it's like voting for them. The more vicious we [caricaturists] become, the more they enjoy it."*

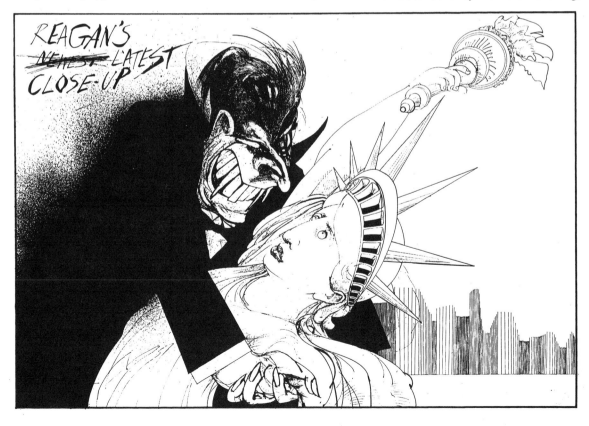

so seriously. I see myself as a court jester who is able to say to the high and mighty, the powerful, 'You are wrong.' That's the only value a caricature really has—it proves to be a rallying point around which other people who feel the same way can gather. I don't think a caricature can change the world, but it can cause people to say, 'That's the way I feel.' "

Because his timely caricatures of newsmakers are distributed nationally by the *Los Angeles Times*, Taylor Jones is fast becoming one of this country's most visible caricaturists. Jones sees his primary role as one of entertainer, whether or not his caricatures make somebody mad. But he says he can't help it. "It's not my intention to throw anybody out of office, but oftentimes the more incompetent, corrupt or ugly the politician is, the better it is for me. We political cartoonists really do profit at other people's expense. When times are bad, the caricaturist does well."

Although his work has been appearing more regularly in consumer publications, "at one time the only place you could find Steve Brodner's work was in the pages of politically oriented magazines that didn't pay much money," says Brodner's friend, fellow caricaturist Sam Viviano. "But at least these forums allowed Steve to say what he wanted. He felt very strongly that if you weren't making a statement with your caricature, somehow you were compromising yourself. 'Selling out' is not quite the right term, but Steve thought you were not being true to yourself."

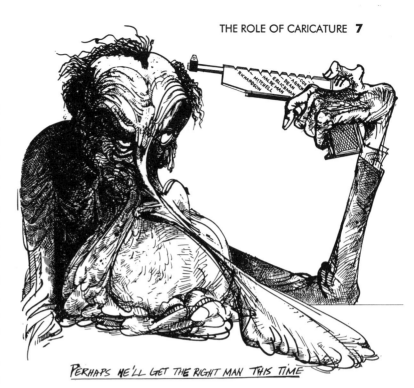

PERHAPS HE'LL GET THE RIGHT MAN THIS TIME

Nixon Self-Nixing. *Gerald Scarfe's vicious caricature of Richard Nixon. "I attack the politicians and people in power," says Scarfe, "who bring about those bad things and perpetrate them on the average man."*

Beast of Burden. *Ralph Steadman caricatures Richard Nixon as Godzilla. Steadman has concocted a rather believable caricature of our thirty-fifth president by merely representing his long, divided nose and indicating his dark, wavy hair.*

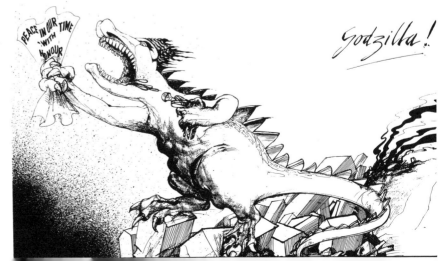

8

Minimizing Lucy. *Robert Risko astutely caricatures Lucille Ball with minimized, airbrushed shapes, forms and lines. "When I caricature," says Risko, "I take a celebrity's features and rearrange and exaggerate them and throw them back at you much like an impersonator would impersonate somebody. It then makes the audience perceive the subject as a little more human."*

LET ME ENTERTAIN YOU

Others approach caricature strictly as a form of entertainment—and make no apologies for doing so. For these artists, caricature becomes illustration—a graphic statement to augment or break up the monotony of an otherwise gray mass of magazine copy. Far from being window dressing, these caricatures which entertain are, in my estimation, no less salient than the politically oriented caricatures.

"The function of a caricature," says Bill Plympton, "is to entertain. But that shouldn't be taken lightly. To entertain someone is a very noble deed, a very difficult deed." Consummate cartoonist and MAD man Jack Davis agrees. "The public likes to look at caricatures," says Davis, "if they don't like the subject, and if he's drawn ugly, they love it— it's funny. But sometimes I think

caricaturists can take cheap shots at their subjects because they can't come back at you—some caricatures can be pretty brutal."

Although his stylistic caricatures are used in major magazines, consumer ads and publications, Gerry Gersten is probably best known for his caricatures of historical and contemporary literati that accompany the Quarterly Book-of-the-Month Club's advertisements and print materials. While Gersten sees caricature to be "essentially hostile," he stops short of labeling the caricaturist a mere entertainer or observer. "Caricature is not just another way of showing what a celebrity looks like," he says, "it's more like a short film that indicates to the viewer what this person is. For the viewer, a caricature is like a handshake, like sitting down and having a sandwich or a glass of wine with that subject, so that at the end

Is It Mascara, or 30 Weight Motor Oil? *Jimmy Margulies' hilarious* Houston Post *editorial cartoon shows Tammy Faye Bakker in a particularly drippy mood.*

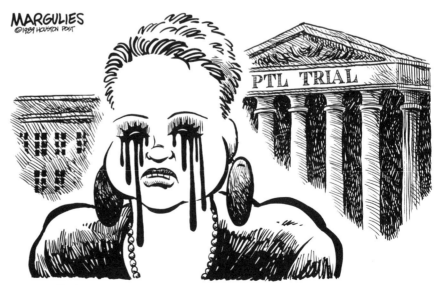

Rain-soaked Carolinas brace for more storm waters

of the encounter, you have made certain conclusions about who that subject is.''

When he caricatures a subject, Bruce Stark (whose work adorns several TV *Guide* covers) says he ''definitely will not try to provoke or make fun or demean anybody. I always try to project some kind of enjoyment for the person who looks at the caricature and for the person who is being caricatured,'' he explains. ''I'm a lot different from those poison-pen guys who really draw those extra-big noses. Enjoyment is what I'm striving for in my

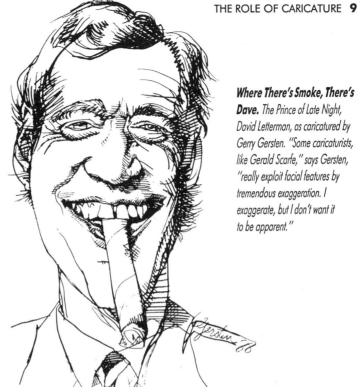

Where There's Smoke, There's Dave. *The Prince of Late Night, David Letterman, as caricatured by Gerry Gersten. "Some caricaturists, like Gerald Scarfe," says Gersten, "really exploit facial features by tremendous exaggeration. I exaggerate, but I don't want it to be apparent."*

A Rose Is a Rose Is a Rose. *And in this case, the Rose in question is Pete as caricatured by Bill Plympton. Plympton views his caricatures as entertainment. "That shouldn't be taken lightly," he asserts. "To entertain somebody is a very noble deed."*

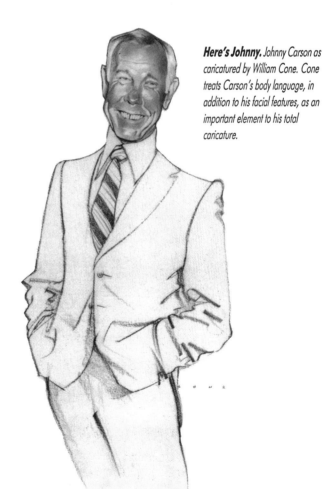

Here's Johnny. *Johnny Carson as caricatured by William Cone. Cone treats Carson's body language, in addition to his facial features, as an important element to his total caricature.*

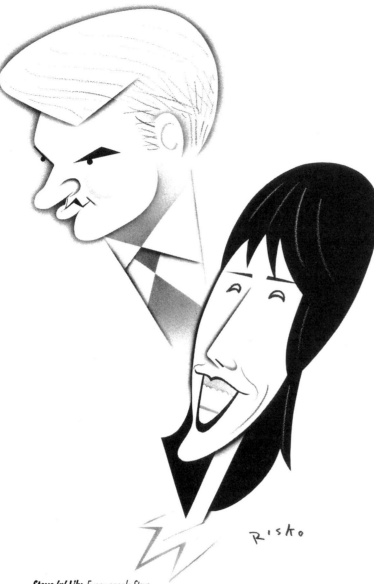

Steve 'n' Lily. *Funny people Steve Martin and Lily Tomlin are caricatured by Robert Risko. Working in airbrush, Risko tries to be "fresh when applying the color to the illustration board. I have to concentrate and not have any distractions. I want to keep the momentum going so the caricatures don't get too labored."*

work. I'm not out to tear somebody down, attack, distort, or make somebody look weird.''

Robert Risko's airbrushed visages are quintessential examples of caricature as entertainment. His lush use of color, composition and hard-edged shapes enables his highly stylized caricatures to exist alone as graphic amusements which seem to lack overt, opinionated inferences to his subjects. When Risko does interject editorial postulation within his caricatures, his kitschy graphic presentation almost always manages to mute it.

''Sometimes,'' says Risko, ''my caricatures are nasty, but since they are in such a pretty package, you really don't realize it. I have always viewed my own caricatures to exist first and foremost as entertainment for myself. I genuinely enjoy distorting a subject's facial features, mannerisms, physical intonations, and personality traits for self-amusement purposes. The theory is that if I'm entertained, moved, inspired, etc., by the caricature, then so will a (admittedly minuscule) percentage of the viewers who see it. The satisfaction is internal—everything else is icing on the cake.''

But in an effort to entertain himself, the caricaturist may slip into a certain smugness by believing that any line he commits to paper will effectively reveal caricature. For instance, there seems to be a recent trend in caricature toward the abstract. While I'm certainly supportive of any and all experimentation down abstract, minimalist, expressionist or Zen paths, I wonder if such efforts run the risk of becoming too parsimonious.

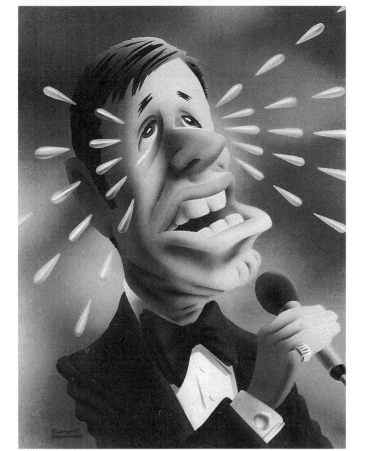

Tears of a Clown. *Self-proclaimed entertainer and marathon fund-raiser Jerry Lewis is caricatured by Robert Grossman. Grossman zooms in on Lewis's conical nose, puppy-dog eyes, greased-back hair, and large, quivering lips. Grossman even interjects some nasty editorialized statement into the caricature by ridiculing Lewis's amazing proclivity to cry at will.*

There's Hope. *Al Hirschfeld caricatures Bob Hope with but a few carefully placed pen lines. "The art of caricature, or rather the special branch of it that interests me," explains Hirschfeld, "is not necessarily one of malice. It is never my aim to destroy the actor by ridicule. My contribution is to take the character—acted out by the actor—and reinvent it for the reader."*

For All You Know, It Could Be Tammy Faye. *Fun drawing, but who is it? Luckily for us, Steve Brodner solves the mystery by attaching the necessary label.*

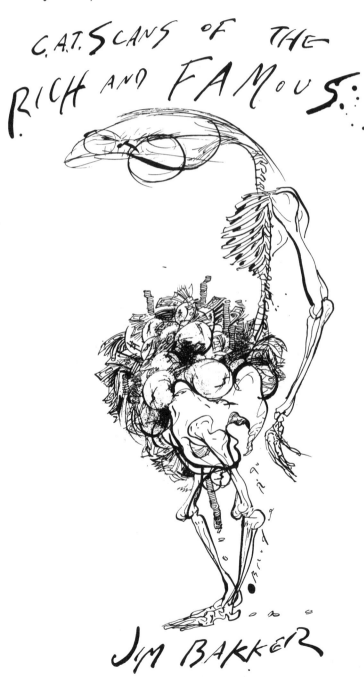

C.A.T. SCANS OF THE RICH AND FAMOUS:

JIM BAKKER

Taken away from the context in which it appears in a magazine (next to a headline, squeezed between explanatory text, augmented by a caption, etc.), a caricature of a subject which has been composed of abstract, vibrant brush strokes or expressive, screeching pen lines cannot be perceived as a caricature of that given, human subject. For instance, while a brilliant editorial statement on a truly abhorrent individual, you'd never guess that Steve Brodner's caricature is that of PTL founder Jim Bakker if it weren't for Brodner's attributing caption. And certainly Ralph Steadman's spontaneously generated caricature of Dennis Conner would not "read" without the visual clues of *yacht* on his hat, the name of his America's Cup-winning sailboat (*Stars and Stripes*) on his windbreaker, and the name of Conner himself in the upper left corner of the caricature.

When such cases occur, I feel a certain uneasiness. In my estimation, caricature cannot be communicated unless the caricaturist understands his role to impart a likeness that is readily perceived. This is not to say that the caricaturist must forsake expressionism, rather he must be cognizant of the level at which his expressionism becomes alienating and counterproductive.

"Caricature," says Bill Utterback, "is meant to entertain and communicate—certainly to communicate the likeness of a subject. A good caricature should really look more like the subject than he really does. A bad caricature is where distortion is done for distortion's sake."

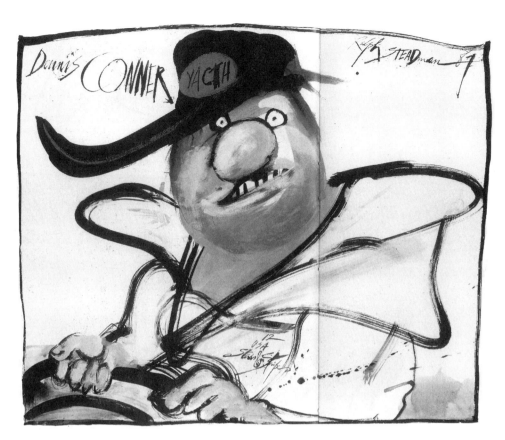

Yachtsman. *If it weren't for Ralph Steadman's explanatory label, you'd never know his caricature is one of Dennis Conner.*

The George 'n' Gerry Show. *Debating vice president George Bush and wanna-be Geraldine Ferraro are caricatured on the cover of* New Republic *by Robert Grossman. While Grossman has exaggerated Bush considerably, it seems he has tempered his airbrush when distorting Ferraro's facial features. Historically, men are graphically lampooned in caricature to a greater degree than are women.*

Look, Ma, No Hands! *Steve Brodner caricatures a ballot-box-pilfering Lyndon Johnson to graphically augment a book review in the* Progressive. *Brodner believes "the whole design of the caricature is important. I'm not just interested in caricaturing the figure itself, but in the whole square patch on the page as an art experience."*

STEVE BRODNER

WHEN CARICATURE EFFECTS CHANGE OR CAUSES REACTION

Indeed, for many caricaturists, reaction—either pro, but especially con—validates the caricature itself. Particularly for a newspaper editorial cartoonist, the lack of response can be perceived as a pretty good indicator that the cartoonist may be missing the mark. On the other hand, a pile of hate mail, a barrage of obscene phone calls, even a death threat or lawsuit attest that the cartoonist is fulfilling his mission.

You can generally gauge an editorial cartoonist's effectiveness by the number of people he's able to enrage. Of all the editorial cartoonists I know, none generates more nasty mail and phone reaction than Paul Conrad, the *Los Angeles Times's* three-time Pulitzer Prize winner. Conrad has been called every name you could imagine by his readers (most of which I would prefer not to print here), but most editorial cartoonists refer to such vehement reaction as validation of their ability to effectively communicate their graphic ideas. Like caricature, editorial cartooning is a predominantly offensive art form, and at best is able to spark debate and reaction.

A political animal in his own right, Steve Brodner admits he gets "very involved by political issues. They follow me into bed at night. But I don't lead myself intellectually into thinking that my caricatures are going to make a difference. I'm thirty-five years old, I've been doing this for twenty years, and have had

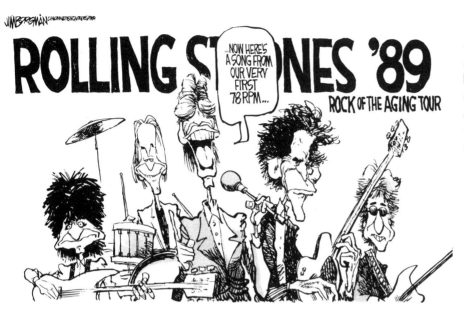

Gathering Moss. Jim Borgman, editorial cartoonist of the Cincinnati Enquirer, offers hilarious caricatures of the somewhat aged Rolling Stones. (Left to right) Ron Wood, Charlie Watts, Mick Jagger, Keith Richards and Bill Wyman.

only one incident in which a drawing I did effected change — and that was probably a freak of nature."

The cartoon Brodner refers to was drawn while he was an editorial cartoonist with the *Hudson Dispatch* of Union City, New Jersey. The piece lambasted the local county freeholders for voting themselves hefty pay increases and caused them to rescind their vote. While such noble results are a rarity, Brodner says the fact does not diminish the "passion" with which he does his work. "It's a disappointment," Brodner admits, "when you don't hear any response to your work, but I still always do my best. People who get really excited about a magazine caricature are really just fans, afficionados — sort of like opera buffs. The rest of the world just looks at them like they're crazy."

For the politically oriented caricaturist, "reaction" means your work is getting through. Although David Levine's satirical drawings rarely result in readership feedback,

Drawing the Line on "Nightline." A 1989 editorial cartoon of mine of Ted Koppel. Usually in an editorial cartoon, the cartoonist can get away by drawing a simplified caricature of a subject because the cartoon's context offers enough clues (news set, desk, stage lights, the word "Nightline") to help identify the caricature itself.

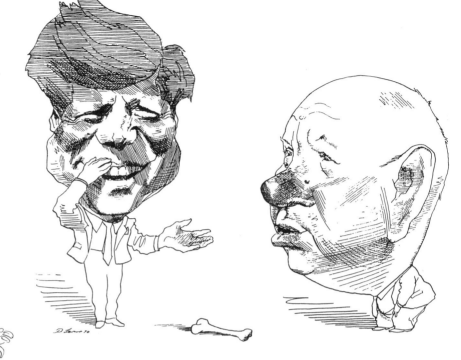

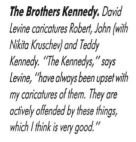

The Brothers Kennedy. *David Levine caricatures Robert, John (with Nikita Kruschev) and Teddy Kennedy. "The Kennedys," says Levine, "have always been upset with my caricatures of them. They are actively offended by these things, which I think is very good."*

his caricatures in the *New York Times Review of Books* have prompted responses from the subjects themselves. "The Kennedys have always been upset by my caricatures of them," Levine points out. "If you question or criticize them, you are perceived as an enemy. I once tried to get into a tennis tournament that Ethel Kennedy was putting on. When I was having trouble getting in, I went through George Plimpton, who was a very good friend of hers. I said, 'George, am I not a celebrity?' 'Yes, of course,' said Plimpton. 'Then why can't I play in that celebrity tennis thing?' Plimpton said he would certainly ask Ethel. He came back very soon and said Ethel says 'No'—that's it."

"On another occasion," Levine recalls, "Teddy Kennedy was in the South visiting some big Democratic money-givers who happened to be collectors of my paintings and caricatures. Senator Kennedy noticed that they had my caricature of Bobby (as neither fish nor fowl), and gestured to take the caricature and throw it out the window. They're very actively offended by these caricatures, which I think is very good. You want somebody to react."

Perhaps the brightest rising star in caricature today is Philip Burke, whose energetic work has caused many people—and even art crit-

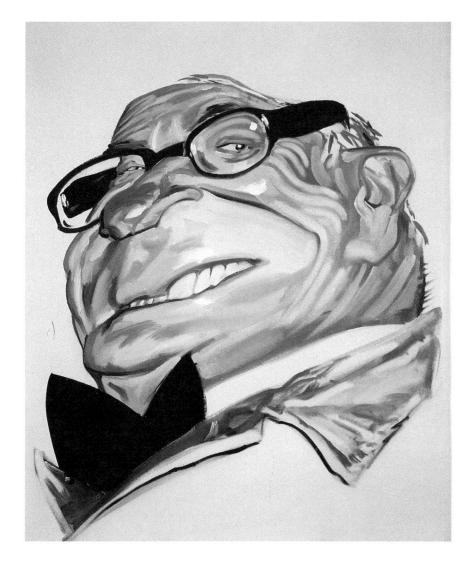

Malcolmtent. *Unabashed capitalist publisher Malcolm Forbes is distorted, exaggerated, squeezed, stretched and further bastardized by Philip Burke. Burke's highly individualized approach to caricature is helping to inject long-overdue vitality into a sometimes stagnating art form. "In the mid-1980s", explains Burke, "I stopped doing caricatures that pointed out a subject's flaws, which is the general history of caricature. Now I use each caricature, like an actor would, to express my own feeling about what it means to be a human being."*

ics—to take notice. Reaction for Burke can come in terms of sales. After his caricature of a celebrity has appeared in Esquire or Rolling Stone, the subject may call Burke to arrange for the purchase of the original painting. John Cougar Mellencamp, Winona Ryder and others have purchased Burke's caricatures of them. Another collector of Burke's work is Doonesbury's creator, Garry Trudeau, who owns caricatures of Magic Johnson, George Bush and the Reagans.

Instead of looking for such a direct reaction from readers, Robert Grossman is satisfied if his caricatures cause a more subtle reaction—his graphics, after all, may pique a reader enough to read the article he has illustrated. Grossman's airbrushed caricatures have been published in every major magazine—from Time to Newsweek, Esquire to Sports Illustrated. If a caricaturist is looking for reader reaction, "he might settle for being happy that the reader saw his caricature," says Grossman. "If the reader gets some sense of what the article is about without reading the story, there is value in that, too."

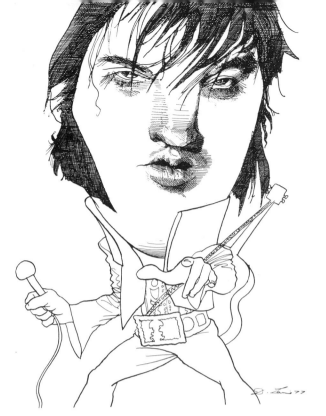

The Real Elvis. One of the few caricatures of Elvis that doesn't put "The King" into a Pollyanna context. Here David Levine has no reservations about caricaturing Elvis as he might have appeared on stage after overimbibing backstage.

A Drawing with Purpose. *If I have any "role" as a caricaturist, I certainly don't believe it to be a terribly pretentious one. While some caricaturists believe their duty is to editorially inject their subjects with vitriolic ink, or mercilessly point out their imperfect physical features, I hope my caricatures provide a chuckle. If I have any sort of "talent" as a caricaturist, it is to graphically represent a subject's quintessential physical traits and mannerisms in a humorous way as to make them instantly recognizable to the reader. So if, for example, a reader is unable to perceive this as a caricature of David Letterman, then I have failed my self-described role as a caricaturist.*

Baking Up a Caricature.
Reagan-era Chief of Staff, Howard Baker, captured wonderfully by Bill Plympton. Baker, after all, does not possess wildly grotesque, easy-to-spot facial features. Nonetheless, Plympton zeroes in on Baker's slit-like eyes, his distinctive, rabbit-toothed sneer, and even his prodigious ears.

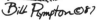

© 1986 Los Angeles Times Syndicate

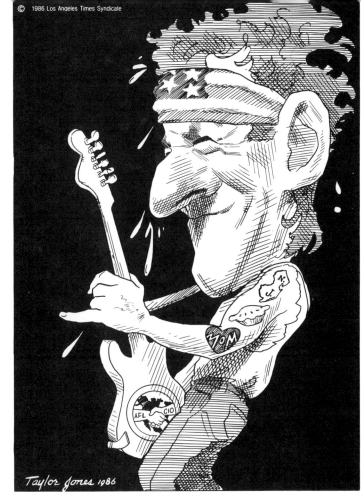

Taylor Jones 1986

Higher Ground. Steve Brodner caricatures Jesse Jackson at the 1988 Democratic National Convention in Atlanta, giving his ironic "Common Ground" speech to party delegates. While Brodner believes his role as a caricaturist is to editorialize, he says he doesn't lead himself "into intellectually thinking that my caricatures are going to make a difference."

The Boss. Bruce Springsteen as caricatured by Taylor Jones. Jones feels that as a caricaturist, his role is to entertain, but, he states, "whether I make somebody mad, I can't help that."

"common ground"
Jesse Jackson, Atlanta
July 19, 1988

Where's Yoko? *The Beatles (a.k.a. Paul McCartney, John Lennon, George Harrison and Ringo Starr) are caricatured by Mark Marek. While Marek's scratchy drawing style is intentionally childlike, his ability to caricature is wonderfully astute.*

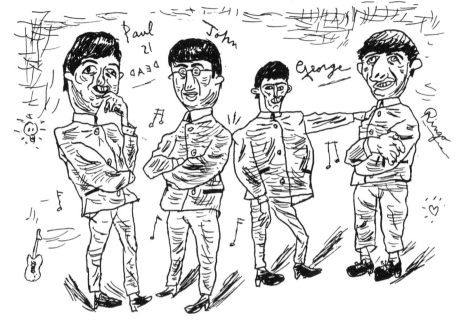

Yup, They're Yuppies, All Right. *The cast of "thirtysomething" is caricatured by Mort Drucker. Drucker is able to straddle the swaggering fence between straight representative illustration and caricatures—the result is a style that's all his. From left to right, Ken Olin, Mel Harris, Timothy Busfield, Patricia Wettig, Polly Draper, Peter Horton, Melanie Mayron and, well, their kids.*

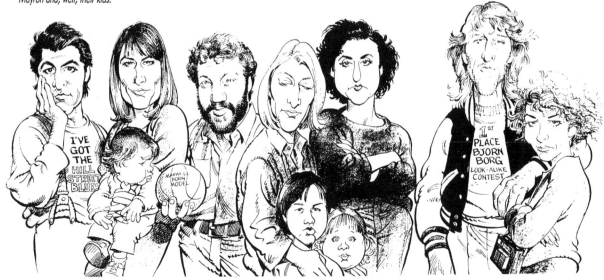

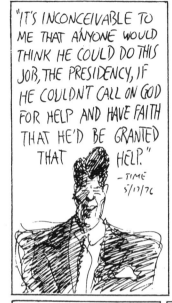

MAY 24, 1976

The Powers that Be. *Ronald Reagan, Gerald Ford, Jimmy Carter, Jerry Brown and even God Himself as caricatured by Edward Sorel.*

2

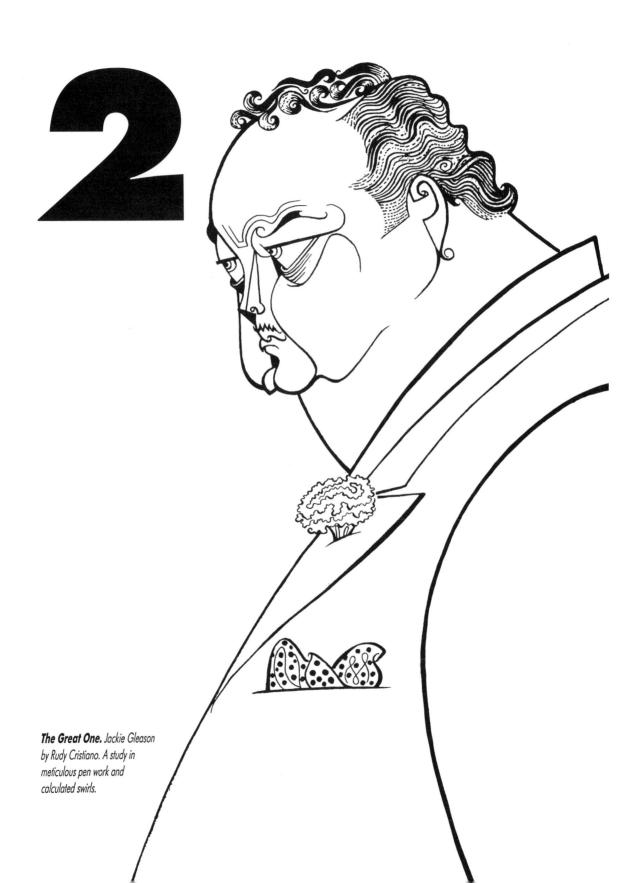

The Great One. *Jackie Gleason by Rudy Cristiano. A study in meticulous pen work and calculated swirls.*

CARICATURE APPLIED

While it could be used more frequently, caricature is utilized in a wide variety of communicative and entertainment applications. From newspapers to magazines, television to advertising, caricature is effectively utilized as a fresh alternative to other commonplace forms of illustration and photography.

Caricature, to be sure, is an extremely uncommon art form practiced by a minuscule handful of graphic specialists—hence its relative rarity. So when caricature is used in communication, it's a welcome, refreshing treat. In general, the public appreciates a good, insightful caricature of a politico, celebrity or familiar face. This is, after all, an art form capable of bringing the mighty down to our level.

NEWSPAPERS

Without a doubt, caricature is used more often in the daily newspaper editorial cartoon than anywhere else. All across the country, readers can turn to the editorial or Op-Ed pages of their newspaper and expect to be bombarded by a barrage of caricatures of politicians, world leaders, dictators, prime ministers, senators and comparable scoundrels.

But while caricature is applied with regularity in editorial cartoons, this does not mean that editorial cartoons are necessarily drawn by great caricaturists. On the contrary, many of today's editorial cartoonists seem to have little regard for caricature as an art form and tend

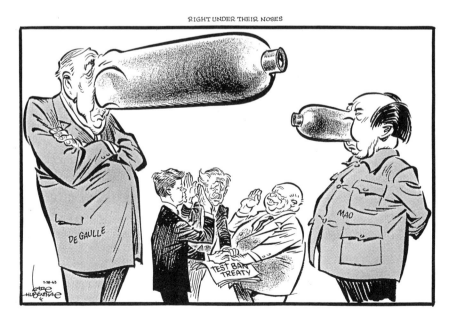

Just Don't Sneeze. Karl Hubenthal's 1963 editorial cartoon showing Charles DeGaulle, John F. Kennedy, Harold Macmillan, Nikita Kruschev and Mao Tse-Tung. Notice the labels which editorial cartoonists added to jackets to identify the figures.

Liposuction. Jim Borgman lampoons (left to right) former presidents Gerald Ford and Jimmy Carter, and George "Read My Lips" Bush.

Hint, Hint. Mike Peters's hilarious 1974 editorial cartoon showing a dimwitted Gerald Ford unable to pick up on Richard Nixon's rather blatant hint. The extraordinary thing about Peters's caricature is how he is able to astutely capture a politician's likeness with minimal strokes of the pen or brush, thereby maximizing their humorous effect.

to attribute trivial importance to its role in the total editorial cartoon.

In fact, until the so-called New Breed of editorial cartoonists (headed by Pat Oliphant, Don Wright, Mike Peters and Jeff Mac-Nelly) stormed on the scene in the early 1970s, most editorial cartoonists resorted to the heinous act of *labeling* their caricatures. History shows that if an editorial cartoon sported a caricature of Harry Truman, you can bet the label *Harry Truman* would adorn his suit jacket. Yet in all fairness, it was the lack of television and other advanced forms of visual communication which necessitated the earlier editorial cartoonists labeling their caricatures. Without their doing so, few readers would have recognized a caricature of a given subject with whom they were not visually acquainted. But today's editorial cartoonist speaks to readerships very aware of how their politicians and world leaders actually appear, so rarely is it necessary to label the caricatures of them.

The fascinating thing about editorial cartoon caricature is that an image will grow and develop with the passage of time. The cartoonist's first caricature of, say, Gerald Ford will be dramatically different

than the caricature he draws of Ford some four years later. Four years, after all, is 1,460 days, and throughout those days the cartoonist subconsciously (or consciously) will evolve his caricature of Ford. With each new caricature, the cartoonist's presentation of Ford becomes modified, improved, more accurate and even abstract. But because the editorial cartoonist's caricature will metamorphose over an extended period of time, its graphic evolution is not so apparent. Like a head of hair, it grays over time, day by day.

When it comes to newspaper editorial cartoons, Gerald Scarfe claims he likes to ''push caricature as far as I can stretch it — I like to stretch the faces as far as I possibly can. If you are drawing for a newspaper, you can eventually convince the public that the George Bush you drew in January is the same George Bush you drew completely abstract by November. People still believe it is

Scarfed. *Gerald Scarfe pushes caricature as far as he can stretch it in drawing President Kennedy.*

I wish I could go to America!

Gerald Scarfe

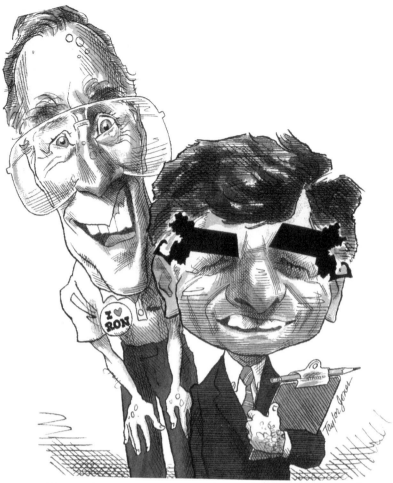

Pick One. *Taylor Jones caricatures George Bush and Michael Dukakis for a 1988 cover of* New Republic. *Jones correctly identifies Bush's head as elongated, while Dukakis's is more horizontally squat. Jones has also added the clever twist of using silhouettes of the state of Massachusetts to represent Dukakis's heavy eyebrows.*

George Bush because you have taken them with you throughout the months you have caricatured him.''

Ford is a good example of a subject who was essentially dropped into the lap of the unprepared editorial cartoonist. When Nixon selected Ford to replace Spiro Agnew, Ford was a little-known congressman from Grand Rapids, Michigan. The public (editorial cartoonists included) had minimal visual and personal knowledge of a man suddenly thrust into the political limelight. Therefore, the first editorial cartoon caricatures were tenuous studies indeed. In fact, *People* magazine devoted a two-page spread to the editorial cartoonist's caricature dilemma in 1974.

The *People* thesis gave graphic testimony that newspaper cartoonists were groping for Ford's identity with their caricatures of the Man Who Would Be President. Caricatures of Ford drawn in 1974 bounced all over the place. Some editorial cartoonists saw Ford as having a high forehead, while others gave him a sloping brow. Many correctly identified the ample space between Ford's nose and upper lip, while others decided that this feature was trivial. It seemed there was no common denominator to the early Ford caricatures.

Yet over time, editorial cartoonists began to recognize what Ford looked like — light, sunken eyes, awning brow, high forehead, an almost benign, gorilla-like visage puffing on a pipe. And if such striking physical traits weren't enough, Ford's personality became symbolic itself. Soon Gerry Ford was rendered as the bumbling fool who continually tripped on stairways — Gerry Ford, the University of Michigan center who played far "too many games with his helmet off" (Lyndon Johnson's assessment). A difficult caricature subject in the early days, Ford swiftly became a favorite subject of the contemporary editorial cartoonist.

But when it comes to newspapers, caricature is not solely resigned to the editorial cartoon. Almost every major newspaper syndicate offers a caricature service to hundreds of client newspapers. And although extremely rare, caricatures appear sporadically in comic strips. Caricatures rear their visages in such strips as *Doonesbury*, *Pogo*, *Outland*, *Shoe* and others. From 1984 to 1987, Mort Drucker drew and Jerry Dumas wrote a strip called

We can **save** the city from the **evil** force that has chosen **New York** for destruction!

Why has this evil force picked New York?

Because it **feeds** on what this city has in such abundance — **anger, hostility, mistrust** and **good delicatessens!**

Who Ya Gonna Call? Mort Drucker. At least that's what MAD *does when they poke fun at a hit movie like* Ghostbusters. *Here Drucker caricatures Bill Murray and Ed Koch, who somehow manages to get into the script.*

Benchley. Syndicated by King Features, the strip was unusual in the sense that it relied on Drucker's formidable caricature skill.

The Benchley character was a White House aide to President Reagan, and each day's strip would introduce some sort of celebrity into the usually convoluted, loosely topical storyline — Muhammad Ali, Spiro Agnew, Jimmy Stewart, Lee Iacocca, Clint Eastwood — they were all seen milling about the White House. Not since *Benchley*'s demise has a comic strip come along that depends so heavily on caricature.

MAGAZINES

And if the newspaper editorial cartoon is almost always a black-and-white affair, with the advent of recent technological breakthroughs in laser separation processes, consumer and trade magazines serve as showcases of color caricature. From *Rolling Stone* to *Esquire*, *Newsweek* to *Time*, *Playboy* to MAD, caricature plays an important illustrative and commentative role.

Applied in a magazine, caricature is usually used to augment or complement text, but some magazines

THE BATTLE OF OPRAH AND PHIL

ARTIST: JACK DAVIS WRITER: FRANK JACOBS

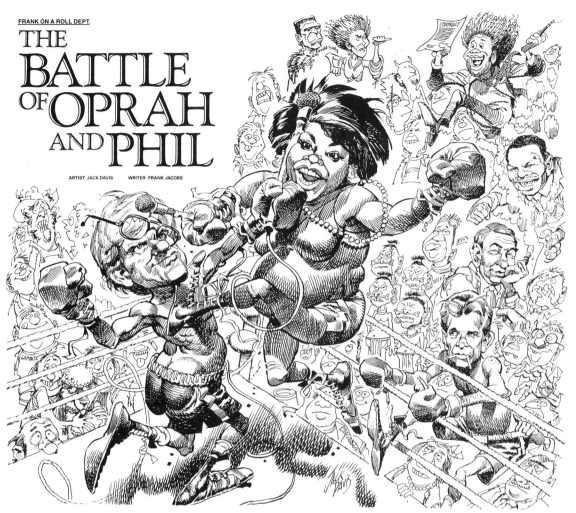

Slugfest. *Jack Davis caricatures Phil Donahue and a pre-diet Oprah Winfrey duking it out over rating points. Davis says, "if they have a big chin, I'll give them a bigger chin. If they have a big nose, I'll give them a bigger nose – but I don't exaggerate those features out of proportion."*

(like *Esquire*) attribute considerable value to caricature as an art form and afford the caricaturist ample space and freedom to express himself. Steve Brodner's magazine caricatures, for example, usually go beyond illustration by functioning as commentary, while Robert Risko's caricatures are commonly employed to complement a magazine article or story in a graphically appealing and entertaining way.

While he claims he doesn't know anything about caricature, publisher William Gaines's MAD magazine is one of the most important forums for caricature. Through their work in MAD, caricaturists like Mort Drucker and Jack Davis continue to inspire

countless cartoonists, both amateur and professional, around the world. And as quintessentially MAD as Davis and Drucker are, it is nice to see that Gaines and company are expanding "the usual gang of idiots" to include such stylistically diverse caricaturists as Gerry Gersten, Sam Viviano and Rick Tulka.

However, MAD is the exception rather than the rule in its steadfast adhesion to a regular stable of caricaturists. Generally speaking, a magazine art director or editor will hire any given caricaturist at a given time to complement an article. The result is a publication's ever-changing, rather than predictably stagnating, design "attitude."

The Thin Man. *Steve Brodner stretches his caricature of George Bush against a Ronald Reagan backdrop.*

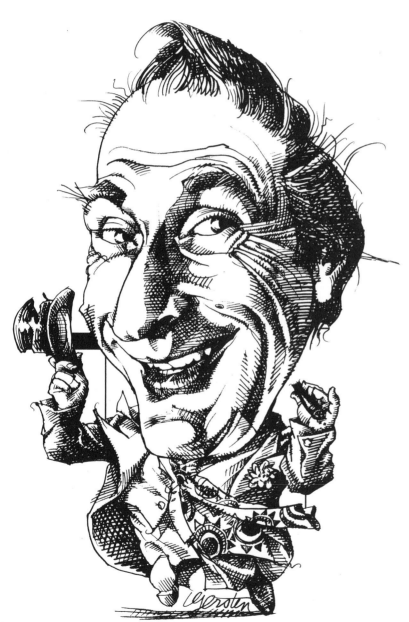

Et Tu, Caesar? Comedian Sid Caesar is big head/little body caricatured by Gerry Gersten for a United Telecom print ad. "Any client," says Gersten, "wants a lot of lines for his money."

Happily, caricature flourishes as an illustration option in magazines. Effectively applied by editors and art directors, caricature can be used as a unique, uncommon form of graphic communication.

ADVERTISING

When it comes to caricature, Madison Avenue has an appetite for the art form, but you certainly wouldn't call it a voracious one. Nevertheless, advertising agencies (on behalf of their clients) utilize caricature for its unique abilities to project humor, add whimsy, and give uncommon dimension to illustration. Agencies use caricature in everything from print ads to huge billboards (each time I drive to the airport, I pass a huge billboard featuring Sam Viviano's caricatures of a St. Louis radio station's deejays).

For the caricaturist, it's tough *not* to be tempted by advertising's mega-money. When you consider that a magazine might pay $1,000 for a caricature compared to the $10,000 that an advertising agency might pop for it, it is understandable that many caricaturists happily take on advertising assignments (provided the client doesn't advocate the clubbing of baby seals, support apartheid governments, or similarly heinous acts—and even then, the caricaturist might be willing to negotiate).

But working for a high-paying agency or client on an advertising gig is not without its headaches. While editorial clients (newspapers and magazines) may extend a fair

amount of creative elbow room to the caricaturist, advertising art and creative directors prefer to keep the caricaturist on a rather taut leash — and because they are being paid top dollar, most caricaturists don't voice much objection to working under such conditions. We all, I suppose, have our price.

About 95 percent of Rick Meyerowitz's work is done in advertising, and when it comes to such caricatures, Meyerowitz is used to tempering his sword (or pen). "I do a lot of caricatures for advertising," he says, "but I do them pleasantly. Maybe after doing a series of celebrity caricatures for a cable TV ad campaign, I might feel like letting off a little steam by doing caricatures of Reagan, Meese or cabinet members — something political. That's much more satisfying than drawing caricatures of five celebrities who will be on cable next week. But for an ad, I do nice caricature."

Taylor Jones says that the stylistic similarity of his caricatures to David Levine's resulted in lucrative advertising work for himself. "It got me a four-year commercial job with American Express," says Jones, "but I hated the job of drawing caricatures of restaurant owners for a little American Express ad that appeared in newspapers all over the country. I did about 400 caricatures, but since it was an advertising account, I had to revise a lot of them, but it paid extremely well. If I had not been drawing in the style I was, I never would have gotten that job."

"Advertising," says Jack Davis, "has always paid better, so I've pursued it more than editorial. In the beginning, however, agencies

Ad Man. *This caricature of Henry Fonda by Al Hirschfeld was used in 1978 to advertise the broadcast of The Grapes of Wrath.*

Cruising. *Bruce Stark caricatures the cast of "The Love Boat" for a 1983 cover of TV Guide. "When I caricature," says Stark, "90 percent of the time I use photographs as reference. Nine times out of ten, I have also seen the person I am assigned to caricature on TV or in the movies. When you have seen so many images of a person, you get a good feel for them because you have seen them from many different angles."*

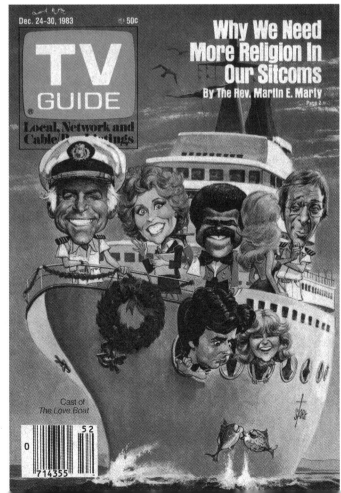

Odd Couple. *Warren Beatty (in his Dick Tracy getup) and Madonna (in one of her many looks) as caricatured by Marcia Staimer of USA Today. Note how Staimer caricatured Madonna in her 1986 "Material Girl" phase (or is that her "Boy Toy" period?). Check your scorecard.*

wouldn't use me, saying I looked 'too much like MAD.' But in 1965, I did an ad series for NBC [which incorporated caricature] and other agencies saw that it worked. From that point on, advertising agencies sort of opened the door for me.''

Generally, I'll come out of an advertising caricature project with mixed feelings—hassles are almost always associated with the experience, but the pay takes the sting out of it. With so many people involved in the job (creative director, art director, account executive, client, etc.), the project almost always becomes a ''caricature-by-committee'' proposition—and the end result is almost always a caricature that I'm not proud enough of to put in my portfolio (or reprint here!).

I'll never forget the time I was hired to do an ad which incorporated two different caricatures of Bud Abbott and Lou Costello. As it turned out, the advertising agency art director didn't have a good visual idea of where he wanted to head with the caricatures (he even made the mistake of bringing in the copywriter to clarify the ''concept,'' a big no-no). What resulted was a long chain of revisions after revisions after revisions. At first, I expressed to my agent how annoyed I was getting with the entire project, but then we considered the fact that the client was being billed for each revision—at $500 per change. Six changes later, I pulled out my calculator and tabulated the fee. Suddenly, all those zeroes looked pretty good. ''Look, let's not complain about the revisions,'' I told my agent. ''In fact, if anything, let's try to *encourage* them!''

TELEVISION AND ANIMATION

Between the I *Love Lucy* reruns and Ginzu knife commercials, you might spot a caricature on television. But don't blink, or you might miss it. Indeed, it is a rarity to spot a caricature on the tube. Occasionally, you'll see caricature used in commercials, sit-coms or game shows, but this is such a scant occurrence, it borders on negligible.

Nonetheless, both Mort Drucker and Jack Davis have worked on television projects in which their caricatures have been animated. Drucker produces a steady stream of caricature for Madison Avenue. For example, Drucker's caricature of Borscht-Belt comedian Henny Youngman was animated for a TV ad, and while Davis has designed a considerable amount of animation for TV commercials, his animated caricature design seems to be confined to character development for a 1972 ABC-TV Saturday morning cartoon series on the Jackson 5.

"I got that job through Arthur Rankin [of Rankin/Bass]," said Davis. "They wanted me to establish the characters of the Jackson 5 so they could be animated. I flew out to Hollywood with my wife. I

Ink Marx. A cel designed by Mike Peters and animated by Minneapolis-based Mike Jones Film Corporation. The animated editorial cartoon, which includes a caricature of Karl Marx, appeared on NBC News in the early 1980s.

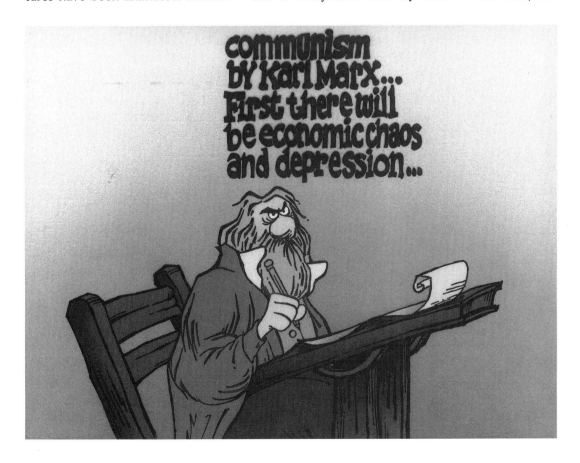

Lightweight. Ranan Lurie caricatures Dan Quayle floating, flying, or maybe he's soaring—in any event, it's obvious he's not grounded in reality.

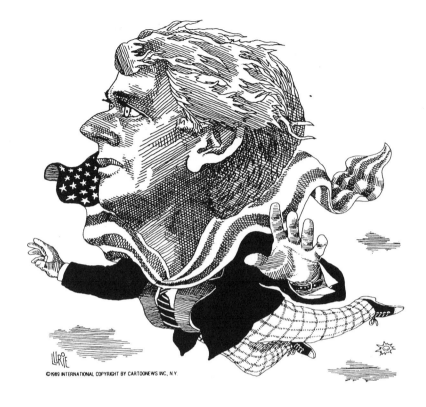

©1989 INTERNATIONAL COPYRIGHT BY CARTOONEWS INC., N.Y.

Let's Party! While he is best known for his humorous illustration in magazines, Patrick McDonnell occasionally manages to slip in a caricature or two, or in this case, three. Ronald Reagan, Nancy Reagan and a tag-along "Hank" Kissinger converge on a party. Like his humorous illustration, McDonnell's caricatures are delightful studies in understatement.

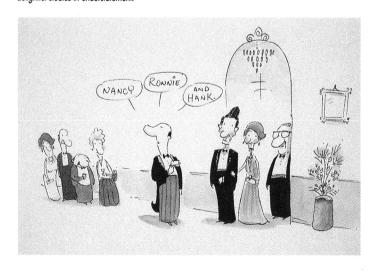

didn't get to meet the Jacksons, but I sat down at the hotel and drew how I thought they should be animated from photographs."

There have even been numerous attempts since the 1970s to animate editorial cartoons incorporating caricature for syndication to network affiliates and independent TV stations, but such efforts have failed for various reasons. *Newsweek* tried one such service a number of years ago using *animatics* rather than cel-by-cel animation.

"Even before that," recalls Pulitzer Prize-winning editorial cartoonist Mike Peters, "there was some [experimental] animation done on the computer which used Paul Conrad, Pat Oliphant, Bill Mauldin and Herblock cartoons. Then, there was another venture in the mid 1970s which attempted to animate edito-

rial cartoons by Don Wright, Paul Szep, Tony Auth and others. Jeff MacNelly's and my syndicate at the time had sold us both to this service, but the resulting animation was so crude that Jeff and I backed out.''

When *Newsweek* announced their attempt to successfully animate editorial cartoons and caricatures, Peters stayed out because he had a special commitment with NBC. ''NBC asked me to do animated editorial cartoons for the *Nightly News* in 1981 or '82,'' Peters remembered. ''We did about three months' worth — three or four a week — in full animation, each twenty seconds in duration.'' But after three months, John Chancellor, then NBC news anchor, ''decided he wanted to do commentaries.'' When Chancellor's commentaries moved in, Peters's

animated editorial cartoon moved out.

After the Peters/NBC relationship terminated, PBS's ''MacNeil/Lehrer Report'' used Ranan Lurie caricatures which were not animated, but would appear to evolve line-by-line on the tube, aided by computer. In the '70s, ''Today'' featured a segment called ''Pen and Ink,'' in which animated editorial cartoons by Jules Feiffer, Jeff MacNelly, Don Wright, Paul Szep and Peters were animated.

My involvement in animated editorial cartoons was a brief one indeed. In 1987, I worked with Ryan and Friends (now Propeller) Animation to develop a fifteen-second feature called *Ink Spot*. I designed a prototype spot which was animated using cel-by-cel drawings, ''cycled'' movements and only four scenes.

Ron and Nancy. *This is a fifteen-second animated prototype for a weekly animated editorial cartoon that I did in conjunction with Propeller Animation of St. Louis. (We decided not to proceed with the project.) In the cartoon, Ronald and Nancy Reagan complain that they "hate reading about Irangate." To solve the problem, they decided to cancel their* New York Times *subscription.*

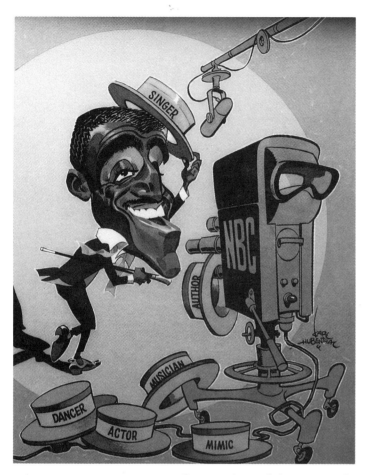

His Biz Was Show Biz. *Sammy Davis, Jr., is caricatured by Karl Hubenthal. Hubenthal effectively uses watercolor to give sculptural, chiseled qualities to Davis's nose, forehead, cheek, mouth and chin.*

But when we showed the spot to the local NBC affiliate in St. Louis, we were told that the concept was terrific but that the cartoon's subject matter had to be strictly local. Thus, we would be creating a weekly animated editorial that would have no syndication value whatsoever. Needless to say, *Ink Spot* faded to black.

On other occasions, I have drawn caricatures for different broadcast applications. I recall being assigned to caricature veteran baseball announcers Red Barber and Mel Allen in a spot for Metromedia Television in Los Angeles, and I did a fair

amount of caricature work for a short-lived NBC game show produced in 1982 by Reg Grundy Productions. I remember little about the show, but it was hosted by John Davidson—hence, there may be a reason why the program came and went without leaving a ripple.

Caricatures of celebrity contestants were used during the opening of "Win, Lose or Draw," the charades-on-a-big-sketchpad TV game show apparently invented by Bert Convy and Burt Reynolds. Ironically, Taylor Jones was hired by the producers of "Saturday Night Live" to draw caricatures on a sketchpad to be used as a prop in "SNL"'s' parody of the "Win, Lose or Draw" show.

"It was difficult," remembers Jones, "because I had to caricature the actors as they were made up to look like other actors, and in the charcoal style of the guy who really draws those opening caricatures for the real show." Hence, Jones was drawing Fred Hartman, made up to look like Burt Reynolds, in a charcoaled line. Worse yet, Jones was paid a paltry $500 for his caricatures. "I tried to get more," he says, "but the show's producers viewed the caricatures as merely props, and that's the prop rate."

SCULPTED CARICATURE

Increasingly, caricature transcends the bounds of the two-dimensional piece of paper by existing in three dimensions. Sculpted caricatures are used more and more as a form of illustration in publishing, advertising and television. Thanks to a

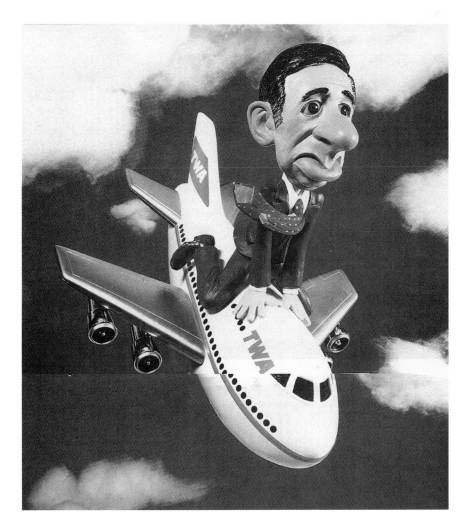

Nosedive. *Even when working in clay, Robert Grossman's caricaturing style is unmistakable. Here Grossman sculpts TWA chairman Carl Icahn preparing to make an unscheduled stop.*

great extent to the popularity of Will Vinton's Claymation™ commercials, a number of caricaturists have found that sculpted, 3-D caricature is accepted as a fresh alternative to flat (albeit traditional) caricature.

For magazine illustration, the caricaturist cum sculptor can create a visage of his subject from clay, specially designing clothing, realistic looking hair, and even authentic glass eyeballs for an eerie, almost lifelike effect. Once sculpted, the caricatures are then photographed against backdrops or within small, constructed sets or environments.

A highly inventive caricaturist on paper, Gerald Scarfe is just as ingenious when it comes to sculpted caricature. In fact, Scarfe has sculpted caricatures of The Beatles, the 1960s comedy team of Rowan and Martin, and John Kenneth Galbraith, which have appeared as *Time* magazine covers. "I get bored just doing black-and-white pen drawings," says Scarfe. "With sculpture, it's a different way of saying the

Brit Spit. *Internationally acclaimed for their clay and puppet caricatures, Britain's Spitting Image Productions shows that the same distortion and exaggeration rules that apply to two-dimensional caricature apply in three dimensions as well. Here, Spitting Image's Roger Law and Peter Fluck sculpt caricatures of Margaret Thatcher, Fidel Castro and Ronald Reagan for* Time *magazine.*

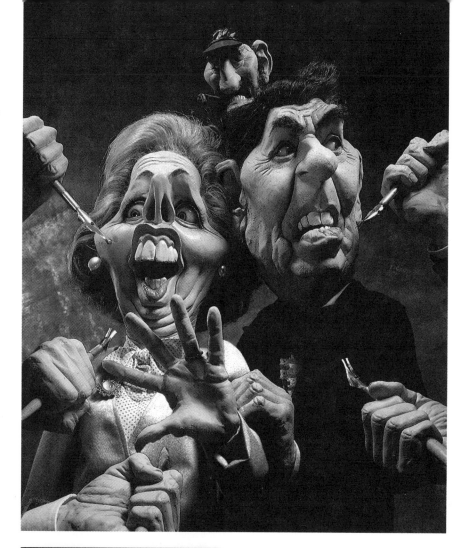

Let's Be Frank. *FDR makes an appearance in the Will Vinton Productions Claymation™ short, "The Great Cognito."*

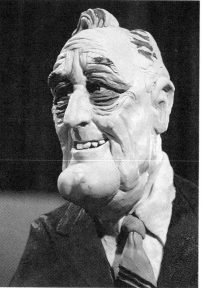

same thing. I like traveling through different mediums."

Recently, caricatures have been "sculpted" as puppets and used in everything from TV shows to music videos. Spitting Image Productions out of London surprised TV viewers when their syndicated show (also called *Spitting Image*) used puppets of Ronald Reagan, Bill Cosby, Johnny Carson, Jackie Onassis, and countless other celebrities to act out relatively humorous storylines. But the uniqueness of the celebrity puppets almost always upstaged the shows' written material. Wildly exaggerated and contorted, the *Spitting Image* celebrity puppets were

even used to give a surreal quality to the Phil Collins music video, *Land of Confusion*.

Following on the heels of *Spitting Image*, a show called D.C. *Follies* premiered in syndication. However, the puppets were far inferior to those created by Spitting Image, and they seemed to be a saccharine response to Spitting Image's nasty, acerbic caricatures. Apparently, D.C. *Follies* was a bar in which Capi-

tol Hill puppet politicos (from Richard Nixon to Oliver North) would exchange Art Buchwaldesque witticisms.

It's difficult to tell if the popularity of sculpted caricature will carry into the 1990s, or whether the novelty will be dismissed as a passing pop-culture oddity. To broaden the appeal of caricature, let's hope that sculptors continue to mold lampooned likenesses in clay.

Masquerade Time. On rare occasions, caricature is used for strange applications. In 1988, Time, Inc., commissioned Sam Viviano to caricature the Bushes and the Reagans (shown here) plus the Quayles, which were then manufactured as masks. "On the night of the inauguration," says Viviano, "Time staged a mock inaugural party in New York. But because the Bushes and Quayles would be in Washington, Time thought it would be a good idea to make the masks. It was an interesting project, and not necessarily the easiest to do. I didn't have the helpful addition of body English or attitude since I was only drawing the subjects from the chin up."

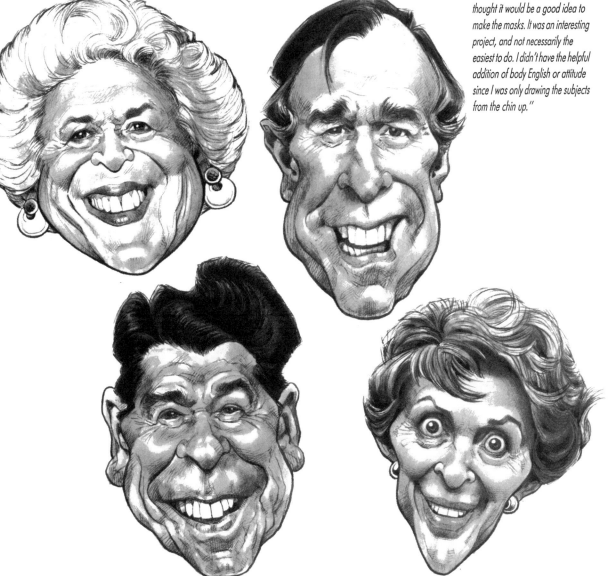

PARTY CARICATURE

Sometimes referred to as *on-the-spot*, *sidewalk* or *live* caricature, the face-to-face encounter between caricaturist and subject is ideally intended as entertainment — a crowd-pleasing element at private parties, bar mitzvahs, corporate gatherings, fund raisers, conventions, promotional events, theme parks, etc. Usually, it is the host of the event who pays the caricaturist (thus making the caricatures free of charge to the subjects), although in some contexts, the subjects pay five or ten bucks for the dubious right to be lampooned by the caricaturist.

The caricaturist is usually set up next to an easel or a large sketchpad is rested on his lap. A big, fat, black marker in hand, the artist has subjects sit in a chair directly opposite him to be caricatured on the spot. Generally speaking, these caricatures are briskly executed within three to five minutes each, but some party caricaturists work at a considerably slower pace. As the caricaturist draws, a crowd usually gathers, and depending on how adventurous they may be, a line of subjects takes form — each waiting to be caricatured. Good party caricaturists are able to entertain the crowd with witty one-liners, jokes

Party Time. A montage of party caricatures created by Sam Norkin. Norkin is able to crank out one caricature every five minutes during a party.

and sarcastic comments, enlivening the atmosphere and adding a light-hearted mood to the event.

While their days of on-the-spot caricature are long over, many of the country's finest caricaturists vividly recall their experiences drawing at parties. "I used to do a lot of bar mitzvahs and stuff like that," remembers Taylor Jones. "But one of the worst jobs I ever did was at the makeup counter of a big department store. Here women were coming to make themselves look pretty, and I was drawing nasty caricatures of them. It made people mad. The store got complaints that I was being very unflattering."

"I dread doing sidewalk caricature," Jones continues, "but when I'm doing it, I have a good time — and I make a big show of it. I have a great deal of admiration for some of these caricaturists at Disney World who draw (usually profiles) at breakneck speed. They make great money, but I can't see them having a lot of fun. Maybe they are, but they don't have a chance to entertain the crowd. What I like to do is get a real crowd around me, and not only draw the subject but comment on their faces and get comments from onlookers. It was always a lot of fun that way."

Though successful today, Steve Brodner remembers the lean days — when party caricature paid the bills. "I worked for fifteen years," says Brodner, "supporting myself by. drawing caricatures of fifty to seventy-five people at parties. In fact, one summer I was extremely broke and sat on the street drawing caricatures at two dollars apiece. I did 50,000 caricatures like that from 1972 to 1986 in New York City."

But the party caricature circuit is not without horror stories. "The caricaturist gets terribly abused by people," Brodner warns, "and I don't recommend it as a line of work. People will come over to you and just demean your work, insult you, tell you that you don't know how to draw. But I was never asked to leave a party. I remember doing a Christmas party, and one of the best caricatures I did I found in the trash in the men's room covered with spittle. The subject was so affected by his caricature that he actively stood there and just spat continually all over the drawing!"

Still, Brodner found that if he was having a good experience at a party, if the people were treating him well, he "hit a kind of zone. Just like athletes do, where your mind is able to block all outside stimuli and you reach a level that you never thought was possible. Something from your subconscious takes over, and as you draw your caricatures you ride along, watching it happen. But those moments were less than one percent of the time."

Personally, the speedy manner in which I draw was always a great asset for a party caricature session.

The nature of the party caricature environment necessitates that the subjects be captured in swiftly flourished strokes rather than in meticulously rendered, laboriously planned lines. I recall feeling a terrific excitement drawing subject after subject in a party surrounding. You couldn't ask for a better exercise in facial analysis than working a couple hours as a party caricaturist. It's down n' dirty, in-the-trenches kind of training.

Two caricaturists who understand the appeal of a quickly executed party caricature are Andre Bergier and Sam Norkin. Bergier has a terrific touch with a hunk of charcoal and uses it to create bold, expressive sweeps. His delightful party caricatures exude a fun, good-humored exuberance (unlike one of his current projects, sculpting nasty caricatures of Fidel Castro, Muammar Qadhafi and Ayatollah Khomeini, which will be manufactured as chew toys for dogs).

Known for his theatrical and celebrity caricatures in such publications as the *New York Daily News*, *Variety* and *Backstage*, Sam Norkin has a high profile that results in steady invitations to draw caricatures at parties, fund raisers and similar gatherings. Norkin uses a fluid, spontaneous line to effectively capture his party subjects.

"I could win a fastest party caricature contest," says Norkin. "I set myself a standard of five minutes per caricature. When I started, I used to do about twenty caricatures an hour, but decided to slow down a bit. I will do things under spontaneous conditions that I would not do

in a studio environment. I take a glance at the subject to determine his most adroit pose—I really draw mentally at that point.''

Norkin has advice for the caricaturist suddenly thrust into a party environment. ''Get your subject to talk,'' Norkin says, ''get them moving—catch them smiling, or frowning. What the party caricaturist has in his favor is the fact that he can pose his subject in the right pose. If a subject looks at you straight on, they may look nondescript, but you move them to a three-quarter view and all of a sudden you see caricature. Instead of plunging right in, the caricaturist should study the subject in a matter of seconds— even using the seconds it takes the subject to sit down in the chair opposite of you.''

Getting "Faced" at a Party Takes On a Whole New Meaning. *From birthdays to bar mitzvahs, New York City's Arnold "Andre" Bergier will be happy to draw and quarter your guests (for a flat fee of $500 for a three-hour session). "I give a guarantee to whoever hires me," says the colorful Bergier. "If you and your guests don't have one hell of a time, there's no charge." From then on, Bergier draws until he runs out of "time, people or paper." Once told by a female party guest to "draw me beautiful," Bergier's deadpan response was, "Lady, I'm a caricaturist, not a magician."*

Getting Faced. *Every year, Playboy calls on Bill Utterback to caricature some of the world's most notable celebs for the magazine's annual "That Was the Year that Was" poetic feature. "I come at caricature," says Utterback, "not as a cartoonist but as a portrait painter. I have always loved likenesses, and I like to think that my drawings have a sense of humor. I am essentially painting in three dimensions with soft edges rather than lines that are two-dimensional."*

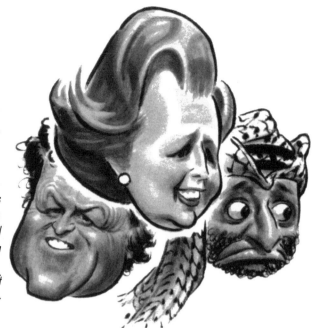

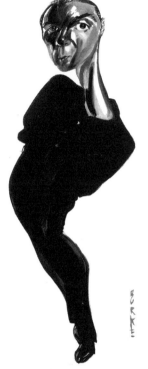

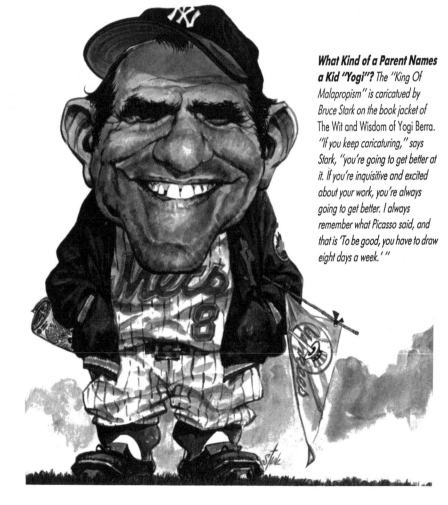

What Kind of a Parent Names a Kid "Yogi"? *The "King Of Malapropism" is caricatued by Bruce Stark on the book jacket of The Wit and Wisdom of Yogi Berra. "If you keep caricaturing," says Stark, "you're going to get better at it. If you're inquisitive and excited about your work, you're always going to get better. I always remember what Picasso said, and that is 'To be good, you have to draw eight days a week.'"*

Byrne by Burke. *Talking Head David Byrne is exquisitely caricatured in Rolling Stone by Philip Burke. "When I caricature," says Burke, "I listen to loud, rock music—Elvis Costello, Talking Heads, The Clash, UB40, English Beat—stuff with intensity and beat, and it has to be hard. Some kind of offbeat rhythm to make my blood boil. Because I work large, it enables me to use my whole body when I paint. The larger I work, the happier I am with it."*

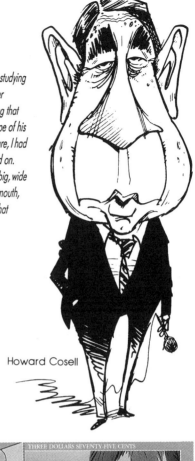

How-To Howard. When studying a photograph of sportscaster Howard Cosell, the first thing that struck me was the pear shape of his head. By sketching that feature, I had a solid infrastructure to build on. Next, I represented Cosell's big, wide nose, sleepy eyes, "lippy" mouth, huge ears, and of course, that toupee.

Howard Cosell

Talk about Saying a Mouthful.
For an article entitled "Don Zimmer Talks Baseball," the Providence Journal's Bob Selby sculpted his caricature of the Chicago Cubs manager out of clay. Clay is a medium that can give a wonderful dimension to caricature.

Gimme Sixty-Five. Robert Grossman caricatures 1988's thirteen presidential candidates all eager for a little hand slapping. From left to right, George Bush, Robert Dole, Alexander Haig, Pat Robertson, Jack Kemp, Pierre DuPont, Bruce Babbitt, Dick Gephardt, Al Gore, Paul Simon, Michael Dukakis, Jesse Jackson and Gary Hart.

JANUARY 25, 1988 THREE DOLLARS SEVENTY-FIVE CENTS

Forbes

NEVER MIND NEW HAMPSHIRE—WHO WILL WIN HOLLYWOOD?

3

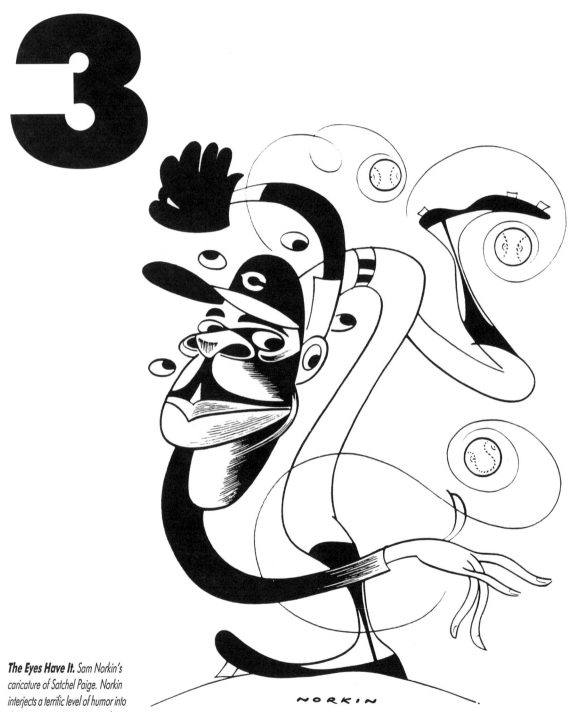

The Eyes Have It. Sam Norkin's caricature of Satchel Paige. Norkin interjects a terrific level of humor into this inventive caricature (even if you do get dizzy looking at it).

CARICATURE STYLE

By simply flipping through these pages, you will see that when it comes to caricature, graphic approaches vary dramatically. Some caricaturists like Al Hirschfeld prefer elegant, sweeping swirls and graceful pen strokes, while others like Philip Burke grind paint into a canvas with bold, frenetic and expressive brush strokes.

Still others like Robert Risko and Robert Grossman rely on technical tools that Michelangelo probably never even dreamed of. For these caricaturists, the airbrush is the preferred weapon of choice—a motor-driven, vapor-spewing marvel which makes the pencil look downright primordial.

But even artists who use similar drawing tools don't always achieve similar results. David Levine and Bill Plympton opt for pen and ink to scratch and crosshatch their caricatures in lines which create the illusion of varied degrees of shading. Although they may use the exact same pen nibs and may render caricatures by using similar pen techniques, they are easily differentiated by one thing—style.

Style, after all, is one of the most precious commodities a caricaturist can possess. Style separates one caricaturist from another and enables us to tell the difference. *Style* is that elusive term that defies definition (and makes this author fish for adjectives).

One caricaturist may stylistically exaggerate facial features to the point of abstraction while another

Wonderful. *Robert Risko caricatures Stevie Wonder. "When I first started doing caricature," says Risko, "I wanted to do the definitive caricature of every celebrity. Today, I'm more easy on myself about doing a celebrity's absolute, final caricature." Risko's style can be descibed as a retro, elegant blend of graceful lines and rich, airbrushed color.*

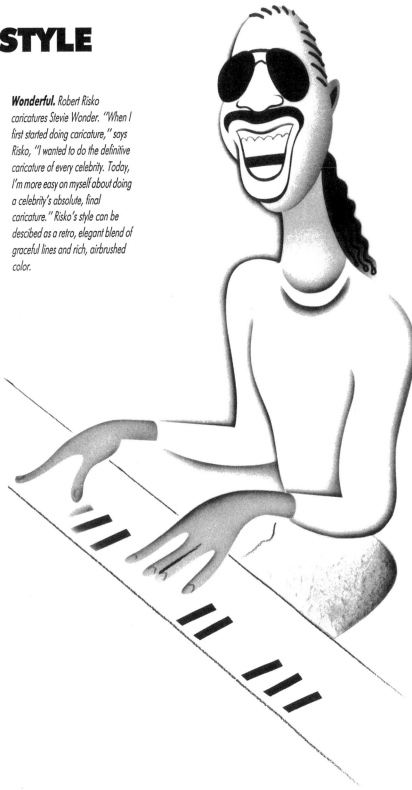

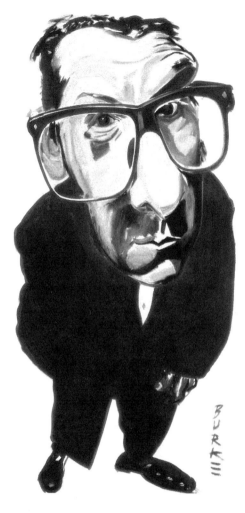

The Elvis Who Doesn't Wear Sequined Jumpsuits. Inventive rocker (and wonderful caricature subject) Elvis Costello is graphically lampooned by Philip Burke.

many American caricaturists become *consumed* by their styles. An examination of Steadman's work shows that the caricaturist certainly does not shy away from stylistic experimentation and happily encourages graphic self-investigation as a way to grow.

"I've often wondered about cartoonists and their obsession with style," says Steadman. "They get 'their style' and then that's that. Some people get 'their style' and then stay there because they feel cozy. But this deadens their work because they are imposing their style over and above their impulsive approach, their spontaneity."

THE ROOTS OF STYLISTIC INFLUENCE

While groping, while learning, while discovering just how to caricature, no caricaturist can possibly avoid being influenced by the masters of his generation. Just as we learned to talk by imitating our nurturing parents, we learn the secrets of this enigmatic art form by looking to historical and contemporary caricaturists for inspiration. In fact, I'd even suggest that the aspiring caricaturist will learn more about caricature by analyzing the illustrations herein than from reading my dissertation. A caricature, after all, is worth a thousand long-winded words.

And while a caricaturist can learn and improve by mimicking another caricaturist's style, the practice must be viewed as experimental or educational. There is nothing wrong with emulating, even copying an-

may slightly distort the same components. One caricaturist may render subjects in wild, spontaneously generated strokes while another may draw them using meticulous, highly planned lines. One caricaturist may lampoon his subjects benignly, another may skewer them with his vitriolic pen. How the caricaturist decides to approach such graphic considerations results in his personal style—his instantly identifiable "look."

However, some caricaturists feel that far too much attention is paid to style. British caricaturist Ralph Steadman, for example, thinks that

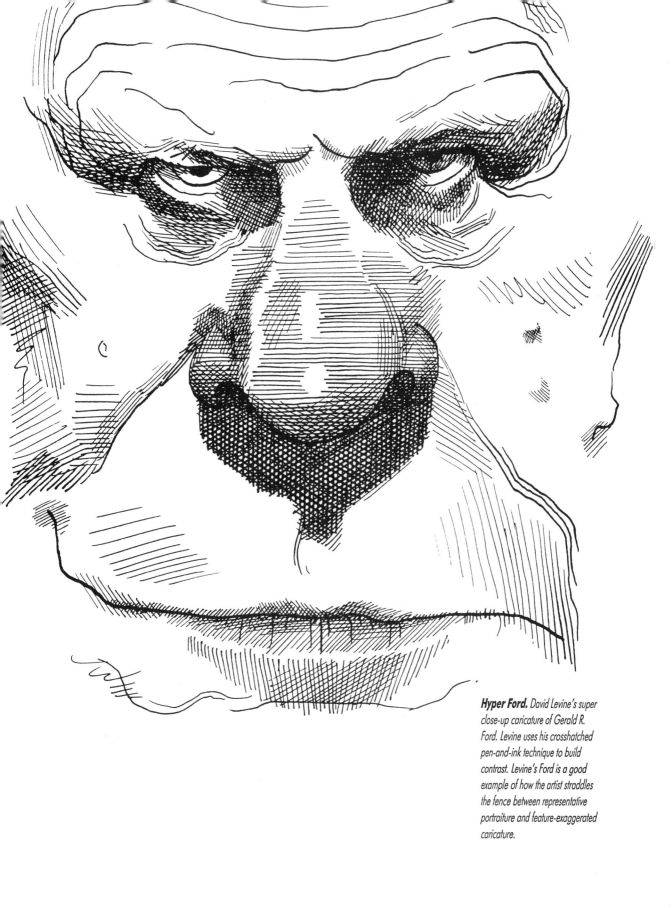

Hyper Ford. *David Levine's super close-up caricature of Gerald R. Ford. Levine uses his crosshatched pen-and-ink technique to build contrast. Levine's Ford is a good example of how the artist straddles the fence between representative portraiture and feature-exaggerated caricature.*

Reagan to the 12th Power.
*Twelve caricatures of Ronald Reagan
show varying levels of exaggeration,
distortion and amplification.*

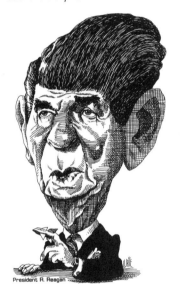

Ranan Lurie

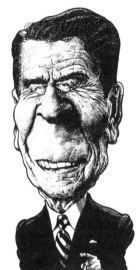

Mike Ramirez

Taylor Jones

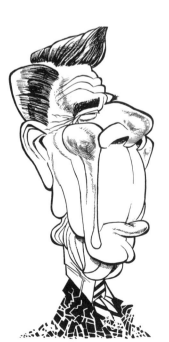

Michael Thompson

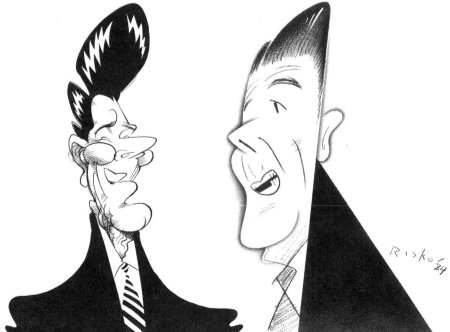

Jack Dickason

Robert Risko

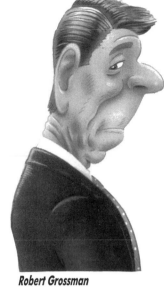

Robert Grossman

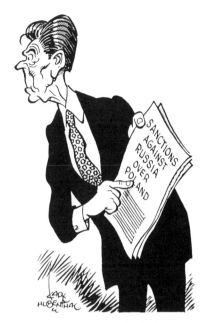

Karl Hubenthal

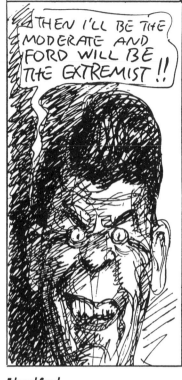

THEN I'LL BE THE MODERATE AND FORD WILL BE THE EXTREMIST!!

Edward Sorel

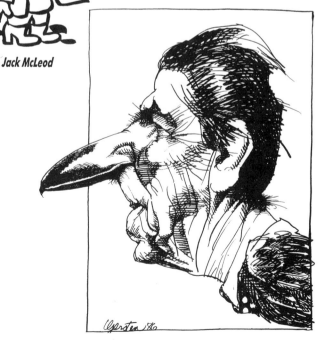

Jack McLeod

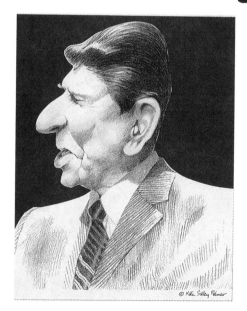

Kate Salley Palmer

Gerry Gersten

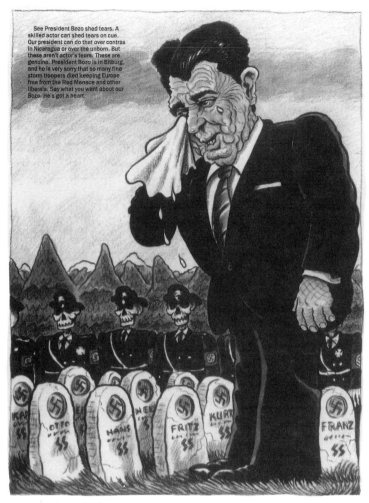

See President Bozo shed tears. A skilled actor can shed tears on cue. Our president can do that over contras in Nicaragua or over the unborn. But these aren't actor's tears. These are genuine. President Bozo is in Bitburg, and he is very sorry that so many fine storm troopers died keeping Europe free from the Red Menace and other liberals. Say what you want about our Bozo. He's got a heart.

Getting Teary-Eyed at Bitburg. *Rick Meyerowitz caricatures President Ronald Reagan shedding a few tears at the Nazi cemetery. After doing a series of celebrity caricatures for an ad campaign, Meyerowitz may "feel like letting off some steam" by doing some nasty, political caricature.*

Famous Folk. *Spot caricatures by Mort Drucker used to illustrate a MAD spread. From left to right, Ronald Reagan, Brooke Shields, George Burns, Howard Cosell and Ann Landers.*

other caricaturist's style—in fact, when you're young, this is a way to improve—but you have to know when to give it up and move beyond incestuous "aping."

When teaching caricature, David Levine encourages his students to look to nontraditional graphic sources for inspiration. "Don't just get hung up on the last [caricature] produced by someone you admire. Go down into the whole field, the whole tradition of drawing, because there is caricature in Leonardo DaVinci—there's caricature in all the great draftsmen—it's only a question of degree."

CONSTANTLY EVOLVING INFLUENCES

While Rick Meyerowitz's style of today is very unique and distinctive, it wasn't always that way. "When I came back to New York after college," Meyerowitz recalls, "my caricature was greatly influenced by Edward Sorel. But I tried very hard not to copy him. Instead, I tried to draw in a way that pleased myself in the same way as Sorel's work pleased me. Some people even thought that my work looked like David Levine. If

I drew in pencil, it looked like Edward Sorel; if I drew it in pen, it looked like David Levine. But I knew the difference.''

When I was a kid in high school, my caricatures looked exactly like Mort Drucker's. Drucker, after all, was the God of Caricature to us impressionable, zit-faced teens weaned on the humor of MAD magazine. In fact, aside from Jack Davis, Mort Drucker has probably influenced and spawned more cartoonists than any other practitioner of this field.

I learned a hell of a lot by literally copying Drucker. By adopting his style, I learned what he was going after when he caricatured a subject — what facial features he was focusing in on and to what degree they were exaggerated. I even mimicked his pen stroke in an attempt to emulate his confident yet spontaneous line. But once I moved beyond the experiment-encouraging environs of the high school paper, I gave up such blatant, yet educational, mimicry — at least until I got into college.

While at the University of Southern California, I occupied a small, cluttered office in the Student Union building, where I was responsible for cranking out one editorial cartoon a day for the *Daily Trojan.*

Darwinism Gone Haywire. *Edward Sorel's hilarious vision of Earth's days as a primordial soup bowl. He skewers presidents (from bottom to top) Ronald Reagan, Jimmy Carter, Gerald Ford, Lyndon Johnson, Richard Nixon, Dwight Eisenhower, Harry Truman, John Kennedy and Franklin Roosevelt.*

The Terrible Two. *Tammy Faye and Jim Bakker as caricatured by Kate Salley Palmer. Palmer has a terrific touch with pen and ink, and her uninhibited line work maintains spontaneity in her caricatures.*

Not surprisingly, my graphic approach was highly influenced by an eclectic mix of the best and the brightest editorial cartoonists of the late 1970s. Pat Oliphant, Mike Peters, Jeff MacNelly and Don Wright all had proved wonderful sources of inspiration (and they all drew on Grafix paper—a unique, chemically activated board which, when used properly, would enable the cartoonist to generate Benday-like halftones. Even today, the paper is used almost exclusively by newspaper editorial cartoonists).

But given the pressures of drawing a daily editorial cartoon in college, I was finding less and less time to actively emulate the styles of various cartoonists and caricaturists (certainly I was still susceptible to subconscious emulation). I found that it took time to find and dig out books and cartoons which I had clipped. I could dramatically reduce the time needed to draw an editorial cartoon by simply drawing an edito-rial cartoon. Once I began to draw from my mind, my own style, my individual voice, began to emerge.

My firm belief is that style cannot be forced—better yet, it shouldn't be forced. The act of caricaturing, after all, should be an enjoyable experience—or at least one that moves the caricaturist himself. Like a tomato seed, style will emerge—in due time. It can't be forced, it can't be aggressively coaxed.

Throughout my professional career as a cartoonist and caricaturist, my graphic style has been in a constant state of evolution. In fact, it is very hard for me to look at work I did three months ago, let alone three years ago, without wincing. After all, today's style is yesterday's graphic experiment.

Michael Witte has had similar evolutionary circumstances. For years, the style of Witte's magazine caricatures would fluctuate—occasionally his pen line appeared fine, while in other publications it bal-

Never a Slave to Style. *Perhaps out of sheer boredom I allow my caricature style to wander and even let my subject dictate how I will linearly lampoon them. For example, Mike Wallace's weathered, craggy face seemed to scream for the rough treatment. In fact, when I caricatured him, I happily ground my black Fountain Pentel into the bond paper on which I drew. On the other hand, I felt that my caricature of Phil Donahue required a better planned line. Once I had cleanly captured Phil's face, I concentrated on his frenetic, horizontal gesturing.*

looned. Yet Witte's experience isn't uncommon, as many cartoonists and caricaturists "hit" their styles in the developing years of their professionally published careers. "My caricature has changed so much in the last fifteen years," he says, "that my old work is almost unrecognizable to me. My style continues to evolve—it will probably never rest at one place. I'm self-taught, and I learned caricature by studying other people's work. I even still voraciously collect illustrations and caricatures of other artists."

Even the venerable Al Hirschfeld, who continues to influence all modern-day caricaturists, was greatly influenced himself by Miguel Covarrubias, the phenomenally talented Mexican caricaturist who emigrated to New York City in 1923. Hirschfeld and Covarrubias were friends—in fact, they shared a 42nd Street studio together—so it is not surprising that Covarrubias rubbed off on Hirschfeld (and vice versa).

Alas, stylistic influence is inevitable. Emulate, mimic and even copy the masters of caricature, but view this practice as a graphic exercise—it's where we all start. As a kid, says Bill Plympton, "I used to copy *Uncle Remus* illustrator A.B. Frost's pen-and-ink style. That's a good idea for young artists—copy someone's style and eventually you'll develop your own style out of it."

Happily, with the aid of caricature examples for inspiration, you can have a degree of success teaching yourself the enigmatic art of caricature. The key is learning when to stop copying and move on to developing your own unique and personal graphic style.

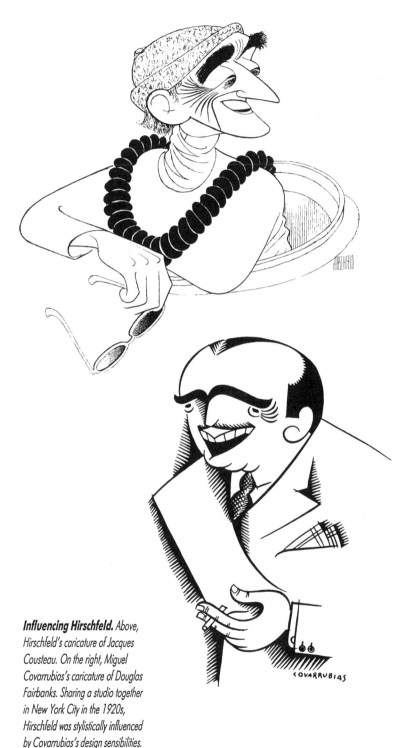

Influencing Hirschfeld. *Above, Hirschfeld's caricature of Jacques Cousteau. On the right, Miguel Covarrubias's caricature of Douglas Fairbanks. Sharing a studio together in New York City in the 1920s, Hirschfeld was stylistically influenced by Covarrubias's design sensibilities.*

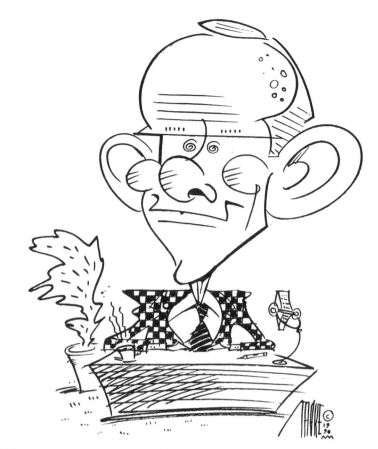

Here's Johnny (and in Stereo).
Johnny Carson caricatured two different ways. Below, Robert Risko renders Carson in airbrush, while on the right, I lampoon Carson in pen. Generally, Risko and I agree on Carson's features (prominent cheeks, hefty ears, even his distinctive smile), but we do see other features quite differently. Risko, for example, sees Carson's nose as a mere button while I perceive it as being more knob-like. We both agree that Carson's eyes are closely set, but Risko renders them as black ovals, while I represent them as airy pinwheels. But overall, Risko and I concur on Carson—we just take different roads in arriving at the conclusion.

QUEST FOR ORIGINALITY

It is almost unthinkable that a truly original caricature style could ever emerge. According to my research, it happened only once. That first caricature, drawn on a musty cave wall with a fistful of squashed berries, was the only caricature which was not influenced by anything other than raw life itself.

It is therefore safe to say that any caricature style is the cumulative byproduct of many visual influences. Since a caricaturist is acutely observant by nature, he soaks up influences from many sources which affect his drawing style. In an age dominated by visual communication, the caricaturist is bombarded by graphic influence wherever he looks—in magazines, in motion pictures, on television, even walking

down the street. The effective caricaturist absorbs these influences, processes them, and uses what he can in his own graphic style. (I, for example, am as appreciative of New Wave MTV graphics as I am of bold, 1930s Bauhaus design.)

Influences can come skidding around any corner. For example, Robert Risko's style is inspired not so much by various caricaturists, but by fashion itself—he has also been highly influenced by the glamorous, commercial airbrush art of the 1940s and 1950s. His style is also marked by a minimalist graphic approach. "When I draw a caricature," he says, "I do a lot of sketches, a lot of studies, a lot of overlays. My 'style' comes in when I ask, 'What do I not need here?'" Risko then reduces his subject and caricature to its raw, essential features. No unnecessary lines or shapes clutter his streamlined caricatures. When Risko renders a caricature, less is more.

"My style is influenced by a wide variety of sources," says Philip Burke, whose fresh approach to caricature is giving the art form some much needed vitality. "Ralph Steadman, Gerald Scarfe, George Grosz, Picasso, Walt Disney—they're all big influences."

"Style is my biggest fear," says Burke. "Most art students today want to know, What's my style going to be? Then they find their style, market it, and when they're forty or fifty they become bored out of their minds. I've tried to run away from style my whole career. I tried to do every caricature differently, and I ran into a lot of problems in the early days getting nasty letters from

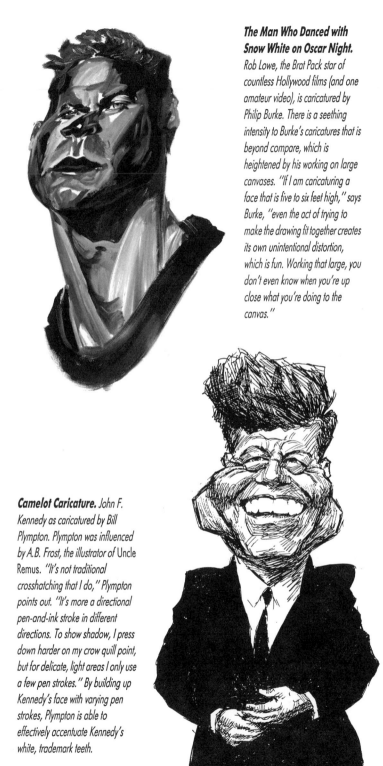

The Man Who Danced with Snow White on Oscar Night. *Rob Lowe, the Brat Pack star of countless Hollywood films (and one amateur video), is caricatured by Philip Burke. There is a seething intensity to Burke's caricatures that is beyond compare, which is heightened by his working on large canvases. "If I am caricaturing a face that is five to six feet high," says Burke, "even the act of trying to make the drawing fit together creates its own unintentional distortion, which is fun. Working that large, you don't even know when you're up close what you're doing to the canvas."*

Camelot Caricature. *John F. Kennedy as caricatured by Bill Plympton. Plympton was influenced by A.B. Frost, the illustrator of Uncle Remus. "It's not traditional crosshatching that I do," Plympton points out. "It's more a directional pen-and-ink stroke in different directions. To show shadow, I press down harder on my crow quill point, but for delicate, light areas I only use a few pen strokes." By building up Kennedy's face with varying pen strokes, Plympton is able to effectively accentuate Kennedy's white, trademark teeth.*

Fit To Be Tied. *"William Buckley Seeks A Cure" is the caption to this caricature by Steve Brodner. Brodner has obviously been influenced by Ralph Steadman's "ink-spewed" pen line.*

Global Cops. *Harry S. Truman and Richard Nixon are caricatured by Edward Sorel. "If you are a spontaneous person," Sorel says, "your caricatures will be spontaneous."*

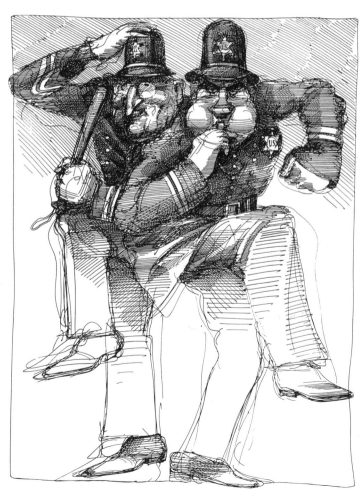

art directors saying 'This [finished caricature] isn't like the sketch you showed me.' But to me, the most important thing was to be doing something different. Now people tell me that when they see my caricatures in print, they know they're mine no matter what. I always try to push it and take caricature a little further.''

The mere manner in which he works allows Edward Sorel to have one of the most unique, instantly recognizable caricature styles around. Sorel used to draw in crayon and pencil in the late 1960s and early 1970s, but today he is known predominantly for his pen-and-ink style. Never penciling out his drawings, Sorel attacks paper with pen and ink. ''This is unusual,'' says Sorel, ''because most artists know where they are going [since they pencil out their drawings and then go over them in ink]. For example, Hirschfeld's swirls are not spontaneous—they are carefully drawn

in pencil first. Like myself, Steadman says he doesn't know where he's going either with his line. Drawing in pen and ink is a sudden-death situation and it gives my caricatures a spontaneous feeling."

While he appreciates caricaturists who draw in a "tight, particular line," Sorel says he can't do what they do. "I'm a spontaneous person, so my drawings are spontaneous. If you are a calculating person, your drawings will be just as calculating. The personality of the caricaturist comes out in the caricature itself."

WHEN STYLISTIC INFLUENCE GOES TOO FAR

While a caricaturist's developing style is certain to be influenced by the work of other caricaturists, there is a fine line between unconscious (even conscious) influence and downright graphic mimicry. The former is a natural, normal and accepted practice, but as a professional, you cross a fine line when you practice the latter.

"There's a distinction," says Steve Brodner, "between learning from someone by imitating him and downright copying of a drawing. The latter is infuriating. I once saw a caricature of Pete Rose which was an absolute copy of a cover I did for *National Lampoon*. I wrote a letter to the artist who copied my caricature and simply urged him to try harder to go beyond the mere copying of someone else's caricature. I feel sorry for people who are so lacking

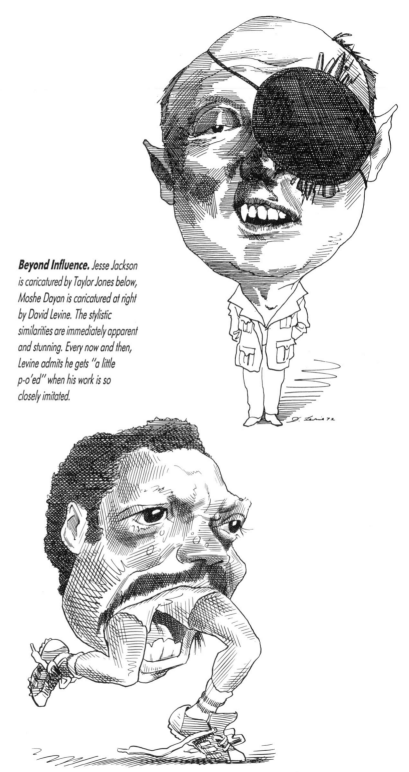

Beyond Influence. *Jesse Jackson is caricatured by Taylor Jones below, Moshe Dayan is caricatured at right by David Levine. The stylistic similarities are immediately apparent and stunning. Every now and then, Levine admits he gets "a little p-o'ed" when his work is so closely imitated.*

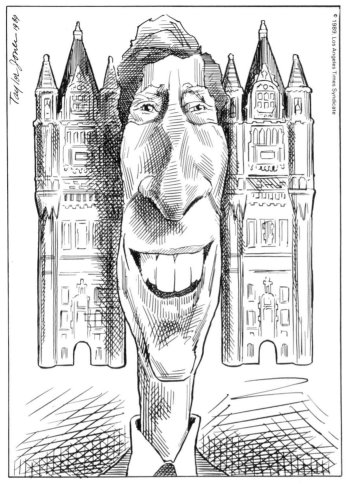

© 1989, Los Angeles Times Syndicate

Ears That Violate British Building Codes. *Prince Charles is caricatured by Taylor Jones. The Prince's already grandiose nose is made more grandiose, his long neck is drawn longer, his closely distanced eyes are rendered even closer. But Jones hedges on the Prince's most distinctive feature — his Dumbo-like ears — by representing them as the towers of London's Tower Bridge.*

in their own artistic standards, who do not possess that inner voice which says 'This [copying] is shameful.' "

Speaking for myself, in moments when I struggle and grope with a caricature, I have been known to pull out an Al Hirschfeld book or a David Levine caricature to see how these masters have captured a certain subject. But when I do so, I am checking to see if my analysis of the caricature subject's features jibes with theirs. Does Hirschfeld, for example, perceive the subject as having widely spaced eyes? Does Levine regard the subject as having a

triangular face or a rectangular one? Once I understand how these masters may have solved these particular caricature problems, I tuck the books away on my shelf — and never leave them open on my drawing table — if I did, the instinct to copy would be excruciatingly tempting.

However, there are still those professional caricaturists who cross that fine line between healthy influence and blatant graphic mimicry. For years, Taylor Jones has made a living drawing caricatures which you would swear flowed from the pen of David Levine. In fact, it is necessary to scrutinize the signatures of these caricatures to determine which is a Jones and which is a Levine. But Jones's stylistic mimicry of Levine is so obvious, so blatant, that you might fail to recognize what an excellent caricaturist Taylor Jones really is. Unfortunately, it is Jones's line-for-line imitation of Levine that hits you square between the eyes — not his astute caricaturing ability.

"I never set out to copy Levine," says Jones, "but I probably understood him too well. My father gave me a book of his as a Christmas gift back in 1969, and I fell in love with it. I had never really paid attention to caricature before. It doesn't really upset me when people say I'm derivative of David Levine — it's something that I've had to live with for a long time. But as far as Levine's style, for a number of years I felt guilty about adopting it, even though I knew that the Los Angeles Times Syndicate picked me up in 1974 because I could draw caricatures like David Levine. But the truth is that I'm extremely busy drawing in a style that is derivative of David

Overlapping Styles. *Gerald Scarfe's work (left) was greatly influenced by fellow Brit Ralph Steadman (below). Here, Steadman caricatures Henry Kissinger, and Scarfe offers a nasty impression of Margaret Thatcher. Steadman says that in the early days, their styles "were exactly alike." For his part, Scarfe says he "can't be concerned with similarities and dissimilarities [in drawing styles]."*

Not Even the Caricaturists Respect Him. *Rodney Dangerfield is caricatured by Rudy Cristiano. While he is obviously influenced by Al Hirschfeld's linear sensibilities, Cristiano's caricature style is all his.*

Mr. Spock and Pete Rose Obviously Use the Same Barber. *Here Spock (a.k.a. Leonard Nimoy) is caricatured by Ranan Lurie. Lurie's drawings utilize the "big head, little body" caricature principle first made popular in the nineteenth century.*

MR. SPOCK (Leonard Nimoy) in "Star Trek V: The Final Frontier."

Levine. It's too late to change. As one cartoonist told me, it's my style now, even if it was someone else's to begin with."

Nevertheless, Jones is frank in suggesting that the derivative nature of his work has probably hindered him in some markets — New York City, to be exact. "New York is David Levine's town," says Jones. "When I would drop off my portfolio with New York editors, they would see the Levine influence and say 'We've already got Levine.'"

However, Jones is by no means the only caricaturist making a living by simulating David Levine's style, but Levine has mixed feelings about his imitators. "Every now and then I'm a little p-o'ed by these imitators, but usually not. It's just one of those things that's happened. It's an extraordinary kind of praise to me. On the other hand, there are times when it's annoying. I used to do work very early on for the *Atlantic Monthly*, and Bob Manning was the editor at the time. A couple of years later, I saw an issue in which they used a caricaturist who did a pretty good imitation of me — some young guy, who didn't use his signature. I was kind of amused by the whole thing, but then I decided to send a bill to Manning. Now, there should have been some sort of a response from Manning but there was none. Not even a ha-ha — just nothing."

Yet Levine is the last to urge that his imitators be banished to exile. "You have to understand," he points out, "that I am an imitator also. What I do is basically a convention of the nineteenth-century 'large head, little body.' There is a lot of resemblance in my pen-and-

ink work to the artists of that period. So, it's not as if I came up with the most creative, different, new style in caricature. For example, I learned a lot about cross-hatching by imitating Sir John Tenniel and Doret."

While his drawing style has evolved over time, Gerald Scarfe's early caricatures looked like they were scratched and spattered by Ralph Steadman himself. When the topic is Scarfe's caricature style and its striking similarity to Steadman's, Scarfe is surprisingly short on words and won't even mention Steadman by name. "I don't like to compare myself with other artists," he asserts. "My work springs from what I have felt ever since I started drawing back in the 1950s. I can't be concerned with stylistic similarities and dissimilarities."

Steadman, however, recalls the first time he met Scarfe. "In 1963," remembers Steadman, "Gerald Scarfe met me at a cartooning convention in London. He came over to me and said, 'I like your line,' and said he'd like to show me his work. Shortly thereafter, we became great friends. After six to nine months, our styles were exactly alike. I would sell a cartoon to a magazine, and then he would sell a cartoon to a magazine. It became like a tennis match between the two of us. Today, Gerry and I have a strange relationship—we don't speak any more."

But if Steadman is insistent about his stylistic influence on Scarfe (and not the other way around), he is just as adamant in his praise of him. "Gerry has taken the line where no one has ever taken it before," Steadman asserts. "He

made caricature an extraordinary sort of thing. He's far more inventive in that really distorted view of things and has been extraordinarily brilliant in things he has done which are his own things. He is his own man and brought something to caricature which I didn't."

Perhaps Edward Sorel best sums up the incestuous nature of caricature and the stealing of style. "I don't get mad," he insists, "when people plagiarize my style. I did my share of it, too. I remember pulling out David Levine's book when I was having problems. Actually, when people copy my style, it bothers my friends more than it bothers me. I'll start getting upset when the copiers get better than me."

Reggie at the Bat. *Reggie Jackson as caricatured by Sam Norkin. Norkin takes the "economy of line" approach to caricature by reducing Jackson's facial features to simplistic, representative pen strokes.*

On the following four pages:
Face Off. *Esquire tried an interesting experiment in 1976, shown on the following four pages. The magazine wondered "how these masters of the skewering pen might feel if somebody did it to them?" So David Levine, Al Hirschfeld, Ralph Steadman and Paul Conrad were all asked to caricature one another. The results are quite revealing and testify to caricature as an impressionistic art form.*

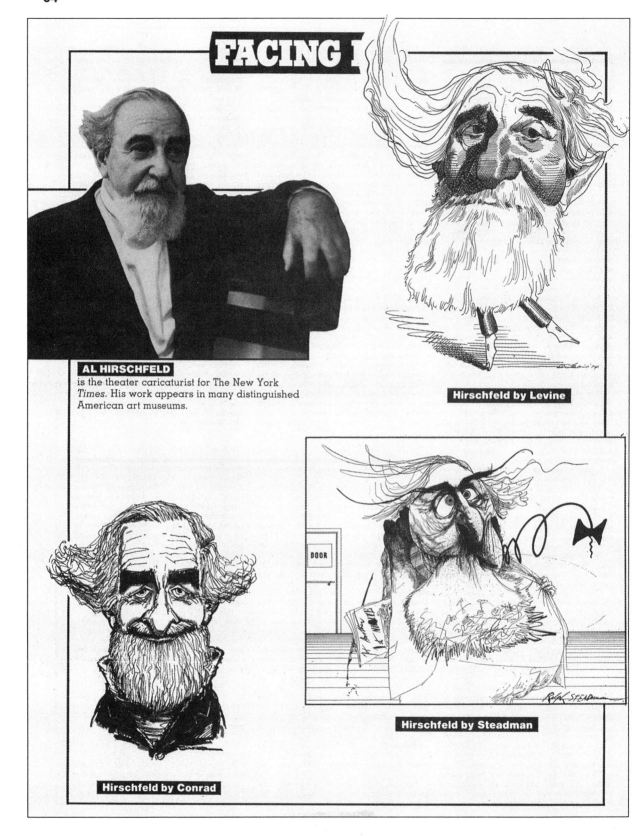

FACING I

AL HIRSCHFELD is the theater caricaturist for The New York *Times*. His work appears in many distinguished American art museums.

Hirschfeld by Levine

Hirschfeld by Steadman

Hirschfeld by Conrad

DOOR

FACING IT

Levine, Conrad, Steadman and Hirschfeld on each other

The fact is, you're not really a bona fide big-time success—show biz, political or literary—unless you've been immortalized in caricature by at least one of these four artists: David Levine, Paul Conrad, Ralph Steadman, Al Hirschfeld. In newspapers and magazines, on the walls of celebrity watering holes and restaurants, their distinctive portraits certify their subjects' fame. How, we wondered, would these masters of the skewering pen feel if somebody did it to them? So we asked each man to have a go at the others—and here are the results.

DAVID LEVINE
lives in New York City. His first published caricature appeared in Esquire more than twenty years ago.

Levine by Hirschfeld

Levine by Conrad

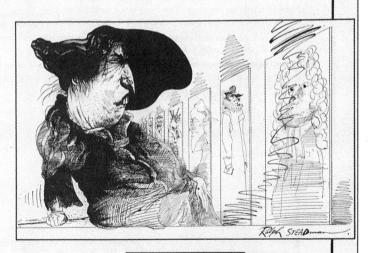

Levine by Steadman

FACING IT

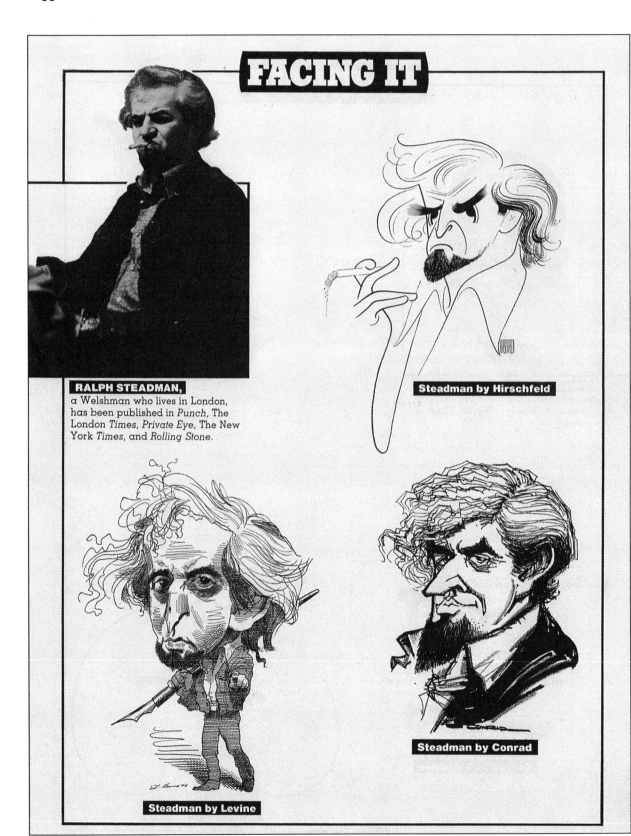

RALPH STEADMAN, a Welshman who lives in London, has been published in *Punch*, The London *Times*, *Private Eye*, The New York *Times*, and *Rolling Stone*.

Steadman by Hirschfeld

Steadman by Levine

Steadman by Conrad

FACING IT

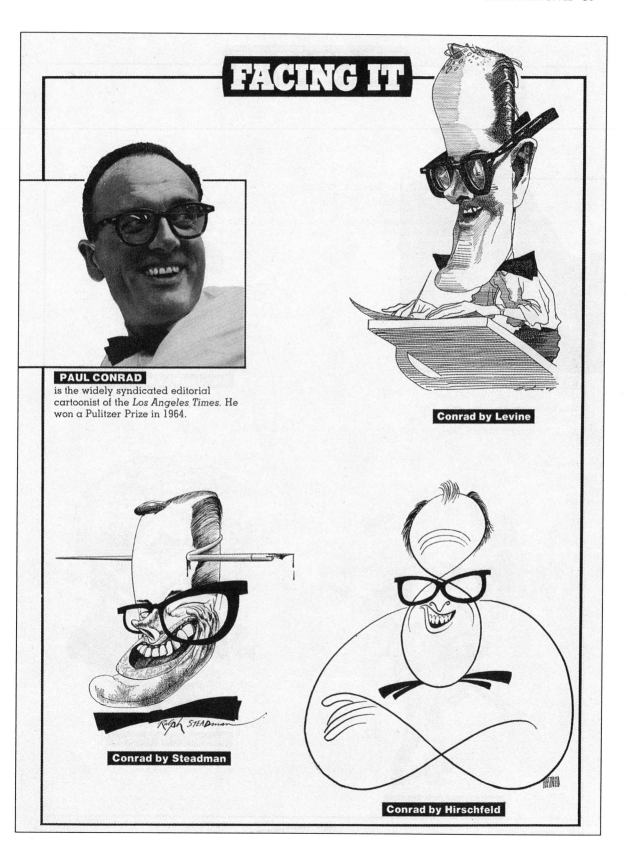

PAUL CONRAD is the widely syndicated editorial cartoonist of the *Los Angeles Times*. He won a Pulitzer Prize in 1964.

Conrad by Levine

Conrad by Steadman

Conrad by Hirschfeld

68

Can I Have A "G," Pat? *Vanna White and Pat Sajak as caricatured by William Cone. Interestingly, Cone's caricatures straddle that wobbly fence between straight portraiture and distorted caricature.*

Yo! *Gary Colby caricatures Sylvester Stallone. Notice the incredible crosshatching in Stallone's face.*

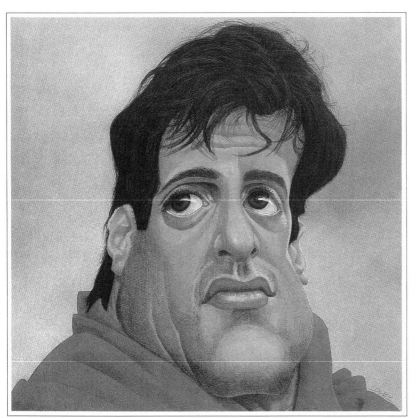

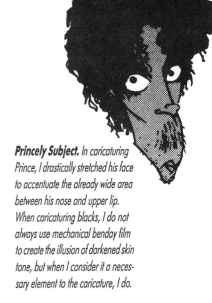

Princely Subject. *In caricaturing Prince, I drastically stretched his face to accentuate the already wide area between his nose and upper lip. When caricaturing blacks, I do not always use mechanical benday film to create the illusion of darkened skin tone, but when I consider it a necessary element to the caricature, I do.*

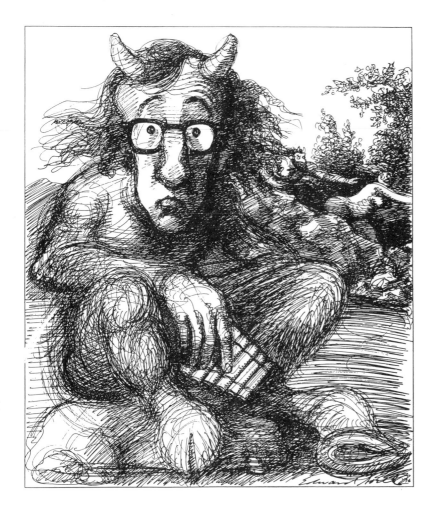

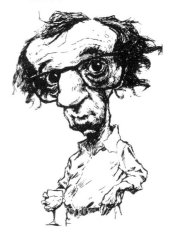

Seeing Triple. Woody Allen caricatured on the left by Edward Sorel, below by Bill Plympton and at bottom by Gerry Gersten. Aside from the obvious differences in straight-on and side views, each caricature exhibits different stylistic techniques, levels of exaggeration, and feature distortion.

Star Searcher and Bandstander. Ed McMahon (left) and Dick Clark (right) are caricatured by Dave Arkle. Note the fact that Arkle's caricatures of the two celebrities are not overly distorted or exaggerated.

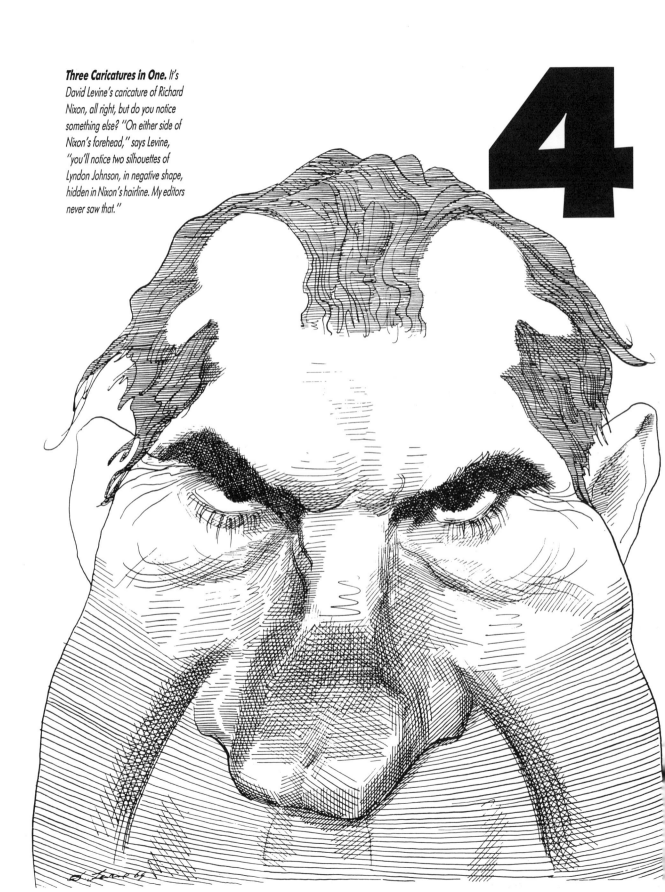

Three Caricatures in One. *It's David Levine's caricature of Richard Nixon, all right, but do you notice something else? "On either side of Nixon's forehead," says Levine, "you'll notice two silhouettes of Lyndon Johnson, in negative shape, hidden in Nixon's hairline. My editors never saw that."*

4

THE CARICATURIST AS "FACIAL DETECTIVE"

A common misconception is that a caricature is simply the graphic exaggeration of a subject's distinguishing facial features. In fact, Mr. Webster himself defines a caricature as "a picture or imitation of a person in which certain features or mannerisms are exaggerated for satirical effect."

But while exaggeration plays a major role in caricature, it is by no means the only consideration one takes into account when caricaturing a subject. After all, not everybody has a huge nose prone to overmagnification and vaudevillian exaggeration. Rather, our noses are different sizes, and more importantly, are different shapes. Likewise, some people have large, prominent lips, while others have thin, inconspicuous ones (the fact that they are inconspicuous makes them conspicuous—see what a bizarre art form this really is?). Caricature, in my estimation, is really an art which depends on graphic *distortion*.

The caricaturist essentially acts as a "facial detective" when he sits down to caricature a subject. His immediate task is to study and analyze the subject to determine which facial features are most prominent (and in what way), and which facial features are insignificant or trifling. It's a detailed decision making process—a skill that improves with experience. I recall eavesdropping on a street artist once who was drawing

caricatures for a few bucks. Somebody asked him how long it took him to develop his ability to caricature. The artist responded "I've drawn about 50,000 caricatures—and I think I'm just now learning how to do it."

How true. The ability to accurately recognize significant and insignificant facial features is perhaps the most important skill that the caricaturist can possess. Without it, caricature itself cannot be created. This is, after all, an art of insight and uncanny perception, and the caricaturist is in essence a graphic impressionist.

IS IT A BIG NOSE, OR A LITTLE ONE?

Whether caricaturing a subject from a photograph, a freeze frame of videotape, or from life, the caricaturist's first response is to make some judgments. What, for example, is the shape of the subject's head? Are the eyes close together, or wide apart? Are the lips full or thin? And what about the nose? Does it resemble an avocado, or a grape? Accurately qualifying these features is the first step to accurate, effective caricature.

For Bill Plympton, the immediate concern is determining the "dynamics" or shape of the subject's head. But the last shape Plympton wants to use is an oval. "An oval," Plymp-

Likable Nerd. *When caricaturing Pee Wee Herman, I wanted to capture his character's borderline naivete and wide-eyed expressiveness. More basic than that, I wanted to project fun. Like an impressionist who impersonates a celebrity's vocal characteristics, a caricaturist does the same thing by lampooning the celebrity's visual features.*

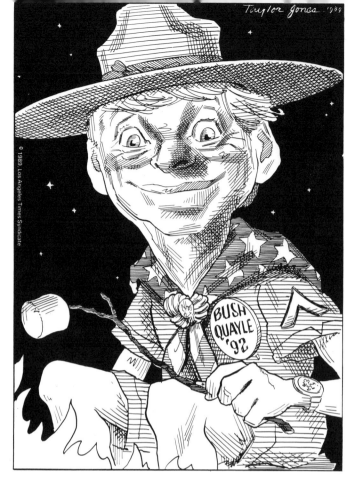

Happy Camper. *Political lightweight Dan Quayle as caricatured by Taylor Jones. Jones says that Quayle was "deceptively easy to caricature. There is something about his hair and mouth that is so perfect for caricature."*

Ted's Head. *Nightline's Ted Koppel is caricatured by Bill Plympton. When focusing on which features to caricature, Plympton first determines the shape of his subject's head. "Obviously," says Plympton, "an oval is not a shape I want to use. An oval is normal and boring. With Koppel, his face is really horizontal, so I exaggerate that. Then I go to the nose, the ears, the hair, the chin, etc."*

ton asserts, "is normal and boring. Take Ted Koppel, for example. His face is really horizontal, so I'll construct a horizontally oriented head. Once I resolve that, the rest is pretty easy. I go into the nose, the ears, the chin, the hair, etc."

However, Taylor Jones focuses in on a subject's eyes first. "The eyes are the key," says Jones. "If you don't effectively capture the subject's eyes the right way, no matter what else you do with the face, it's not going to look like the person. After the eyes, the mouth is the second most important feature. When you are caricaturing someone's face, you are constantly justifying the dimensions of the face. But if someone has a big nose and you make the nose bigger, you have to make sure that you don't throw the face so out of proportion that it becomes unwieldy."

I, on the other hand, find it best to start with the subject's nose. For me, focusing in on the proboscis gives me a solid framework which I can work outwardly from. I also find that the degree to which I distort the nose is generally maintained throughout the rest of the caricature. If the nose is rendered as a wildly exaggerated, conical shape, chances are the characteristics of the eyes, mouth, head and hair will be just as adventuresome and abstract. However, if the subject's nose is innocuous or uneventful, I tend to temper my pen when drawing the subject's other facial features as well.

Because I do not pencil out my drawings (I take ink directly to paper), I have sort of a spontaneous, hit-or-miss approach to caricature.

When caricaturing a subject either from photographs, videotape or memory, I make a quick analysis of the subject's face. Is the head vertical or horizontal? Are the eyes beady or full? Is the distance between the nose and upper lip great or small? Does the individual have a strong chin or a nonexistent one?

Once I have a feel for these features, I'll start to push around the pen. Again, I'll start with the nose. If I'm able to correctly represent the nose, the rest of the features pretty much follow suit. When it comes to the eyes, I study them to determine how light or dark they are. If a person has lightly colored eyes, I tend to represent them as dart boards, diminishing circles, or merely as pinwheel swirls (the latter seems to have been a technique first originated by Miguel Covarrubias and then applied by Al Hirschfeld, but many caricaturists have adopted this trick). If the eyes are dark and commanding, I'll play them up. Likewise, if they are insignificant or beady, I may only represent them as small black dots.

When it comes to the mouth, I study the lip structure. Are the subject's lips large? Are they thin? And what about their color and texture? Once I have determined these characteristics, more times than not I'll see the caricature start to take form. The hair will come next, and I'll start defining the shape of the head, the jawline, etc.

However, it is important to note that sometimes the subject determines which features I will focus in on first. If the subject has a high forehead (Tom Hanks), I may draw that feature first and build around

Critical Caricatures. *Even before sitting down to caricature film critics Gene Siskel (below left) and Roger Ebert (below right), I had a good mental image of what they look like. To refresh my memory, I pulled out a copy of* Spy *magazine which sported the duo on the cover. I was able to bang out a solid caricature of Siskel immediately, but Ebert turned out to be another matter. Ebert would seem like an easy subject for a caricature, but he's not. His eyes are there, but they hide behind glasses. His nose is neither small nor large, but once I added a flaring nostril, his beak made sense. Finally, I drew his rather prominent lips and—tahdah!—a face only a mother could give a thumbs-up to.*

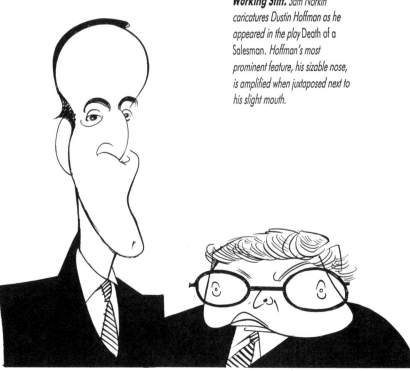

Working Stiff. *Sam Norkin caricatures Dustin Hoffman as he appeared in the play* Death of a Salesman. *Hoffman's most prominent feature, his sizable nose, is amplified when juxtaposed next to his slight mouth.*

'If you've seen one President, you've seen 'em all . . .'

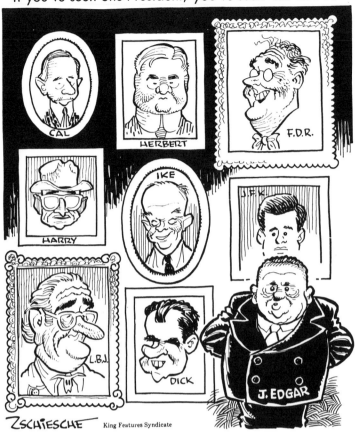

ZSCHIESCHE King Features Syndicate

it. If the subject has an immense head of hair (Ted Koppel), I'll pick up on that first. It really depends on what feature(s) strike me as the most dominant, and I will then adjust the caricature sequence.

Yet after I have drawn my caricature, I may feel that there is something that doesn't quite click. Maybe I've incorrectly drawn the eyes as beady—maybe I've drawn the mouth too large. When this is the case, it's time for a little reconstructive cosmetic surgery.

Let's say it's apparent I've incorrectly captured the mouth. I'll simply redraw the mouth on a separate piece of paper, cut it out with an X-Acto knife and lay it down over the existing mouth. I may then find that I must shift the mouth entirely (usually it is the shift that dramatically

They Were Framed! *Eight presidents and one paranoid FBI director as caricatured by Bob Zschiesche. This editorial cartoon wonderfully illustrates the uniqueness and diversity of facial features—note how differently each president's nose, eyes, mouth, etc., are caricatured.*

Morton Downey, Jr. Five Times. *It took five sketches before I was satisfied with my caricature of TV oddity Morton Downey, Jr. Studying a single photograph of Downey taken from a three-fourths angle, I was able to concoct a relatively solid side view with the sketch farthest to the left. In the preliminary sketch, I was able to correctly recognize Downey's facial features. In the second sketch, I enlarge Downey's*

mouth, teeth and eyebrows, but the distortion goes too far. With the third sketch, the caricature really starts to gel as I realize how important Downey's tree trunk of a neck is to the total caricature. I try to get his mouth and eyes larger in the fourth caricature. By doing so, I push the caricature farther away from instant recognition. So I take the best elements of the third sketch and refine them for my final caricature.

improves the total caricature). Once I am pleased with the new mouth and the position of it, I will simply coat it with glue or adhere it with spray mount to the original drawing. It is amazing how I am able to transform a weak caricature into a strong one by working in this cut-and-paste manner.

OTHER "FACIAL SLEUTH" TECHNIQUES

When determining how he will distort a caricature subject's features, Gerry Gersten puts himself in a sort of self-imposed trance. "When I view the photograph of the subject," Gersten reveals, "I really stare at it in a trance-like manner. I then turn my head away for a few seconds and then look at the picture again to see where the impact is. Is it in the eyes? Is it the distance between the nose and the mouth? Or is it the nose itself?"

But Robert Grossman looks at the whole subject, not only the face. "I start with a generalization," he says. "I determine if the subject is tall, squat, boxy, angular or bird-like—and who knows—maybe the subject looks like a refrigerator. I use the same type of thinking that you apply when drawing objects—like showing if a car is swift (by giving it speed lines) or if it's old (and is dented)."

By doing drawing after drawing, study after study, Philip Burke discovers the dynamics of his subject's face. Before doing his final painted caricature for publication, Burke

OCTOBER 3, 1988 THREE DOLLARS SEVENTY-FIVE CENTS

Forbes

THE RICHEST ENTERTAINERS

ELVIS PRESLEY DIED IN 1977. GUESS HOW MUCH HE WILL EARN THIS YEAR?

Heaven Knows Elvis Is Dead. The King of Rock 'n' Roll is caricatured by Robert Grossman singing to heaven's SRO crowds. "I wouldn't be surprised," says Grossman, "if some day they would create a computer program to do caricature, but it would be terrible. What a caricaturist does involves his whole life experience, education, and some indefinable thing that makes it all work."

That's the Ticket. Former "Saturday Night Live" star John Lovitz is caricatured by Philip Burke. Already a funny-looking person in real life, Lovitz has his facial features pushed by Burke as far as they can go.

Talk about Seeing Dots before Your Eyes! Mike Ramirez's caricatures of Muammar al-Qadhafi and Corazon Aquino consist of at least 582,657 dots (hey, I personally counted 'em!). When he sits down to caricature a world leader, Ramirez takes along a spare drawing hand just in case he has a blowout. What's interesting is that even though Qadhafi's and Aquino's eyes may be incorrectly juxtaposed to one another, the effect doesn't seem to destroy the integrity of the caricatures.

does "a lot of preliminary work. I could draw anywhere between thirty to eighty drawings of the subject. If I'm working from photographs, I may draw very meticulous, straight, realistic drawings from as many angles as possible just to learn the dynamics of how the subject's face is put together. Then if I have a video of the subject, I'll pause the tape and do sketches — all these different images are being settled into my brain. When I know how the face fits together, I then start doing sketches where I begin to distort the features."

Although approaches may vary, the strength of a caricature depends on the caricaturist's ability to correctly validate facial features. Each facial feature incorrectly distorted by the caricaturist pushes the caricature further and further away from instant recognition.

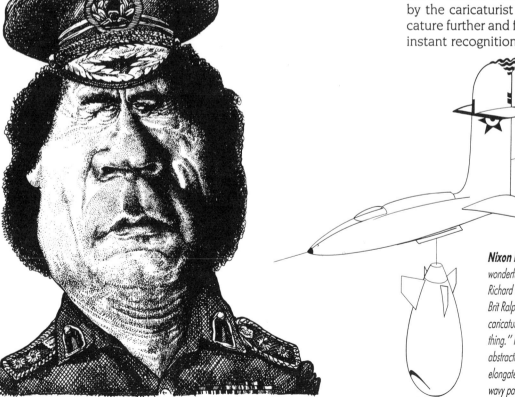

Nixon Bombed. Gerald Scarfe's wonderfully inventive caricature of Richard Nixon. "Gerry," says fellow Brit Ralph Steadman, "made caricature an extraordinary sort of thing." Note how Scarfe has abstracted Nixon's jowly cheeks, elongated nose, sinister eyes, and wavy pate.

CARICATURING THE PLAIN, THE NONDESCRIPT AND THE BEAUTIFUL

Occasionally, the caricaturist is faced with the hellish task of drawing someone seemingly devoid of pronounced, "caricaturable" facial features. After scouring photographs or videotapes of the subject, it becomes painfully apparent that the subject's mug is as exciting as a bowl of day-old oatmeal.

Simply stated, plain faces are extremely hard to caricature. When faced (no pun intended) with the task of caricaturing a physically nondescript subject, the caricaturist can find himself acutely frustrated.

But many times, the caricaturist only discovers during the actual caricaturing process that the subject is a "tough draw." Once he has cranked out twenty, thirty or fifty little sketches that don't effectively capture the subject, he knows that something is going wrong. When this happens, the caricaturist calls a time out and analyzes the situation.

Jack Davis remembers that Henry "Scoop" Jackson [Senator from the state of Washington] was very difficult to caricature. "He had a really average face," Davis recalls, "which was hard to capture. But when I'm having problems caricaturing a subject, I either walk away from the drawing board or try to get more photographs. You've got to slow down, put some good, quiet music on and just relax and do your thing."

Because he works primarily with tracing paper, Gerry Gersten can easily shift features around when he

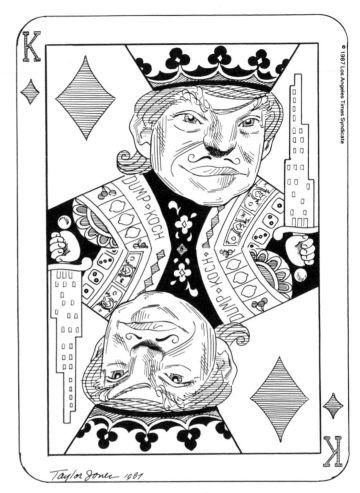

© 1987 Los Angeles Times Syndicate

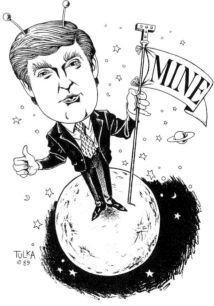

Trump, the Caricature. *"The Donald" is caricatured on the right by Rick Tulka. Trump has a rather "plain face," but Tulka nonetheless picks up on his most caricaturable features like his small, pursed lips, wirey eyebrows, somewhat squinty eyes and, of course, that hair. Taylor Jones, however (above), sees Trump as having a broader mouth, flatter nose, and fuller eyes, but the bushy eyebrows and ample hair remain.*

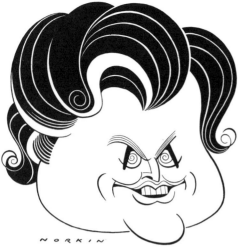

NORKIN

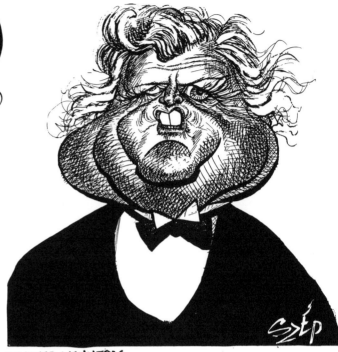

SZEP

SEN. TED KENNEDY

One Kennedy, Two Styles. The Ted Kennedy caricature above is by Sam Norkin, while the one on the right is by Paul Szep. While Norkin captures Kennedy with minimalistic, sweeping swirls, Szep takes the crosshatch approach. Nevertheless, both caricaturists agree on Kennedy's features. However, Norkin's caricature is nonoffensive and lighthearted, while Szep's has an acerbic, caustic bite to it.

Big-Time Senator. This comes very close to being a cheap shot. I've over-exaggerated Ted Kennedy's bloated appearance by giving him an extra two hundred pounds, but the decision to do so was based on graphic considerations. Each time I caricature Kennedy, I tighten up his facial features a little more. The wideness of his body emphasizes the small features.

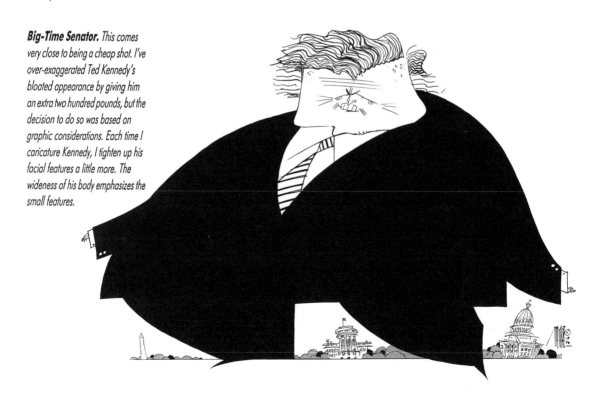

is having problems caricaturing a difficult subject. "When the caricature doesn't quite lock in—and you know when it doesn't—I just shift the individual features," he says. "Sometimes it's not just moving the nose up or down, sometimes it's something as minimal as shifting a nostril—sometimes I move the nose up so that the distance between the nose and the mouth is a little more exaggerated. And you know, sometimes a movement of as little as an eighth of an inch will be the difference between a mundane and a terrific caricature."

But if a plain face is difficult to caricature, according to Bill Plympton, so is an attractive one. "It's difficult to draw handsome people," Plympton asserts. "Movie stars like Paul Newman are difficult because their characteristics are more normal. Ugly people have large ears or big noses or no chin—and that's easy to draw. When someone is handsome, it's hard to exaggerate.

But when I'm having difficulty caricaturing someone, I just keep drawing by doing ten, twenty, thirty, forty little sketches (one to two inches in height) of the subject. I'll draw the shape of the eyes, add a little gesture for the nose, the ears, the mouth. I'll then build on the one feature that I find captures the person best."

Occasionally, the caricaturist realizes that looks (and big noses) can be quite deceiving. A caricaturist may sit down to caricature a person who would appear an ideal subject for caricature but isn't. Taylor Jones recalls caricaturing Barry Manilow: "I once spent about eighteen hours trying to caricature him," Jones recalls. "But his nose was so big you couldn't do anything with it. Once I drew that nose, I couldn't fit anything else on the face! It proved to be an impossible task, and it was frustrating not being able to draw someone who is so funny looking in the first place."

What's the Diff? *Six Bill Plympton caricatures are lined up side by side to dramatically show the amazing differences in facial features. From left to right: Harrison Ford (as Indiana Jones), Supreme Court Justice Sandra Day O'Connor, Michael Jackson, humorist Garrison Keillor, Burt Reynolds and Dustin Hoffman. Note the difference between O'Connor's smile and Jackson's. See how Keillor's jawline juts on either side while Hoffman's recedes? Observe how Reynolds's dark eyebrows negate his eyes, while Ford's eyes squint.*

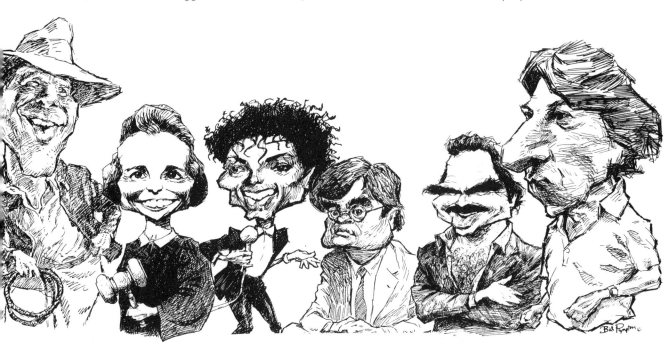

HIS OWN WORST ENEMY

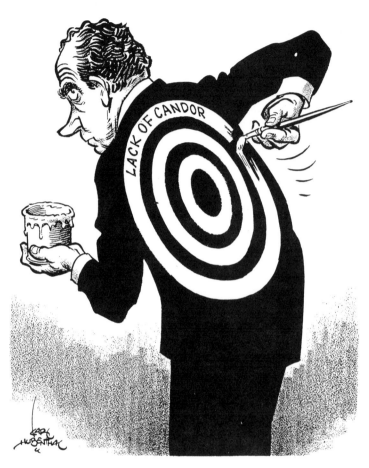

Bull's Eye. *Karl Hubenthal's caricature of Richard Nixon. Hubenthal has always astounded me with how adept he is at handling an ink-dipped brush. The result is caricatures which have an appealing, spontaneous look.*

When presented with an assignment to caricature a beautiful, nondescript or plain face, I take it as a personal challenge. It's easy, after all, to caricature a George Burns, quite another to caricature a Harrison Ford. But by constantly analyzing and sketching the subject's enigmatic features, you become able to represent them correctly in graphic terms. And in the end, nothing compares to the thrill of accurately caricaturing a tough subject.

WHEN PERSONALITY COMES INTO PLAY

Perhaps the quintessential caricature subject is Richard Nixon. Throughout his political career (and particularly during Watergate), Nixon was universally caricatured as having five-o'clock-shadowed jowls, shifty eyes, and of course, a long, hugely exaggerated nose.

Nixon was the type of character whose physical characteristics were almost transcended by his persona, and as his "shifty" personality became more apparent as years went on, caricatures of Nixon began to expose his suspect personality.

"Nixon is a prime example," says Bill Plympton, "of personality coming into play with caricature. Caricaturists added the five o'clock shadow, humped his shoulders, made him look a little sleazy and greased back Nixon's hair. Nixon was a prototype where personality was all over his face. There was no way he could hide what he was." Over time, Nixon's personality became his strongest feature—not his

baroque, easy-to-caricature nose.

But personality is not always apparent in the flat, two-dimensional photographs which the caricaturist must draw from. To perceive personality, the caricaturist must have prior knowledge of the caricature subject. Today a caricaturist will have a strong idea of Ronald Reagan's personality because he has been quite literally bombarded with photos, video, and an eight-year avalanche of information about the former B-movie actor. However, if the caricaturist is faced with the task of caricaturing a relatively unknown celebrity who has suddenly been catapulted into the limelight, the subject's personality is not so apparent or easily perceived. When this is the case, the caricaturist is almost always forced to rely on the distortion of the most apparent physical features and to forsake editorializing about the subject's virtuous or villainous personality.

To effectively caricature a subject, Gerald Scarfe says he must "feel that person's personality. Like an impressionist gives an imitation of someone (by mimicking their voice, their movements), I do the same thing with a line. A caricature to me is not just a big nose, big ears, and big head on a little body—it is much more."

Steve Brodner says his best caricatures are of subjects whose personalities are evident. "Caricature after all," says Brodner, "is an outlet for self-expression. It's difficult for me to draw someone whose personality I don't know. But when I have something to say about a subject's personality, I feel pressure to

Pugilistic Literati. *Steve Brodner's caricature entitled "Norman Mailer 'Lit' into Gore Vidal" recounts the somewhat legendary fight between the two novelists. "Distortion," says Brodner, "is a wonderful tool to create an interesting image, and it helps bring the reader's eye around the page."*

Dave's Dork. *Larry "Bud" Melman, a regular foil on "Late Night with David Letterman," as wonderfully exaggerated by Pete Wagner. Wagner pushes this caricature to the brink of hilarity by slavishly distorting Melman's button nose, lens-magnified pupils and broad mouth.*

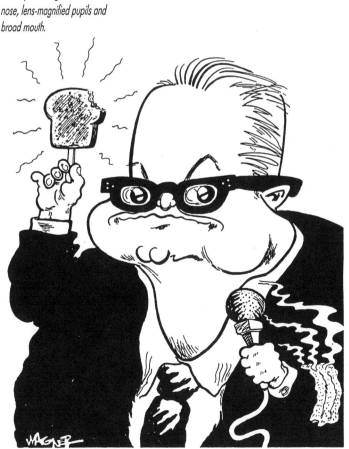

Degrees of Distortion.
Madonna above, Arsenio Hall on the right. You will note that Gersten distorts Hall's features more readily than he does Madonna's. "It is implied," says Gersten, "that you caricature women as pretty and attractive as can be. You realize that men are fair game, but you have to be nice to women."

Morning Person. *Jane Pauley-successor and NBC "Today Show" cohost Deborah Norville is caricatured by Philip Burke. While Burke sometimes approaches caricature as portraiture, you can see how he selectively distorts certain features (lips, jawline), while realistically representing others (eyes, nose).*

do a spectacular caricature when a statement has to be made."

CARICATURING MEN AND WOMEN: DIFFERENT STANDARDS?

At the risk of sounding sexist, there is one way to caricature a man and quite another to caricature a woman. With the former, there seems to be an unwritten law that any facial feature is fair game for slapstick distortion. If a man has a nose which resembles a pickle, many caricaturists will exaggerate it as a watermelon. If a man's eyes are framed by crow's feet, they'll be caricatured as if they were stamped in his skin by an ostrich. When it comes to the male subject, all is fair in caricature and war.

When given the task of caricaturing a woman, many caricaturists will temper their pens. While this practice is particularly evident during on-the-spot "party caricature" sessions, it is quite commonplace as a general rule of caricature. The underlying projection is that a man can laugh at his physical imperfections, while a woman cannot.

While a stereotype, there is some validity in the assertion. Particularly within the environment of party caricature, more men than women seem overtly amused when their facial features have fallen victim to the caricaturist's insightful pen. However, I have seen a woman toss her martini into a party caricaturist's face after he (correctly) gave her a nose slightly larger than a toucan

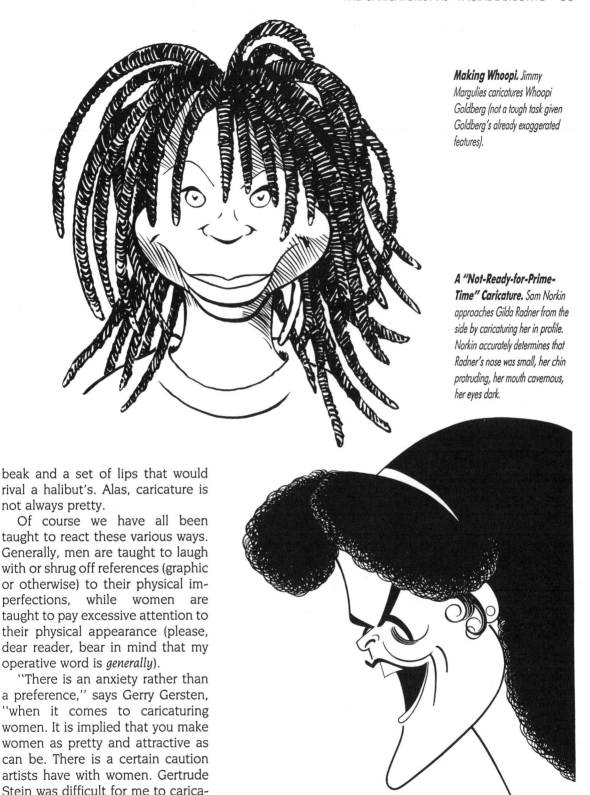

Making Whoopi. *Jimmy Margulies caricatures Whoopi Goldberg (not a tough task given Goldberg's already exaggerated features).*

A "Not-Ready-for-Prime-Time" Caricature. *Sam Norkin approaches Gilda Radner from the side by caricaturing her in profile. Norkin accurately determines that Radner's nose was small, her chin protruding, her mouth cavernous, her eyes dark.*

beak and a set of lips that would rival a halibut's. Alas, caricature is not always pretty.

Of course we have all been taught to react these various ways. Generally, men are taught to laugh with or shrug off references (graphic or otherwise) to their physical imperfections, while women are taught to pay excessive attention to their physical appearance (please, dear reader, bear in mind that my operative word is *generally*).

"There is an anxiety rather than a preference," says Gerry Gersten, "when it comes to caricaturing women. It is implied that you make women as pretty and attractive as can be. There is a certain caution artists have with women. Gertrude Stein was difficult for me to carica-

ture, but I tried to say 'woman' with her eyes because she really looked like a man. There is some gentlemanly caution when caricaturing women, but this is not a conscious thing. You realize that men are fair game, but you have to be nice to women.''

''I tone down my pen when I cari-

cature a woman,'' reveals Bill Plympton. ''It has to be lighter. You can't use a lot of heavy blacks because you have to give a more delicate feel to the drawing.'' And even though Steve Brodner's caricatures of men are rendered in raw, spontaneously scratched pen strokes, he admits that he ''softens'' his tone

Seeing Double. *The Dolly Parton above is by Bill Plympton, the one at right by Robert Risko. In analyzing Parton, Risko and Plympton arrive at generally the same decisions regarding the singer's features, but they do not concur on everything—particularly Parton's nose. And while the caricaturists both note Parton's rather prominent eyelashes, they each have different ways of conveying their prominence.*

Side by Side. *Take a look at these two caricatures by Marcia Staimer of USA Today. On the left is Barbara Walters, on the right we have Oprah Winfrey. Note the difference in how Staimer has caricatured their respective facial features. Walters's head is more horizontal, while Winfrey's is rounder. Winfrey's eyes are spaced widely apart while Walters's aren't. The ability to recognize and validate these facial features is the key to effective caricature.*

when caricaturing a woman. When Robert Grossman failed to tone down his caricature of Hollywood "Super Agent" Sue Mengers in *New York* magazine, Mengers had some harsh words for Grossman. Through her secretary, Mengers told the caricaturist that she wished his hand would "fall off."

Even when I am assigned to draw a series of caricatures, I generally draw the men with energetic strokes and take my line in a more minimalist path when caricaturing the women (the less lines, the less opportunity to offend?). While I'm not necessarily displeased with the overall results, I am almost always most pleased with the male caricatures, simply because they have been drawn with a more confident, exciting line. Nevertheless, I find it fascinating that such benign sexism exists everywhere—even in the righteous (ahem), male-dominated profession of caricature.

Long Face, Wide Hair.
Gilda Radner (a.k.a. Rosanne Rosannadanna) as caricatured by Bill Plympton. Notice how Plympton is able to interject a level of animation into the caricature by slavishly bending Radner's facial features, expression and gestures.

Like a Virgin. What Hell Hath Madonna Wrought? Why, Sean Penn, of course. Wonderfully nasty (and sacrilegious), these caricatures by Ori Hofmekler are rendered to appear painted on a cracked, Renaissance-era canvas.

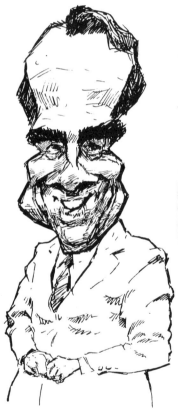

Doling Out a Caricature. Bill Plympton caricatures Kansas Sen. Bob Dole and even accurately draws Dole in his ever-present gesture of aiding his war-paralyzed right hand with his left. Such a touch proves that Plympton is indeed a perceptive caricaturist.

BEYOND FACES: MANNERISMS, "FRUITY WALKS" AND PHYSIQUES

Certainly, a caricature can be much more than a distorted portrait of the features north of the subject's collarbones. While a caricature tends to sink or swim with the effective graphic lampoon of the subject's head, other elements of the person can contribute to a more complete caricature. A caricaturist, after all, caricatures a subject's body by using the same rules applied to the caricaturing of his facial features.

Al Hirschfeld, of course, is the master of caricaturing the body language and mannerisms of his subjects. When Hirschfeld caricatures Fred Astaire, you feel him dancing. When he caricatures Elvis Presley,

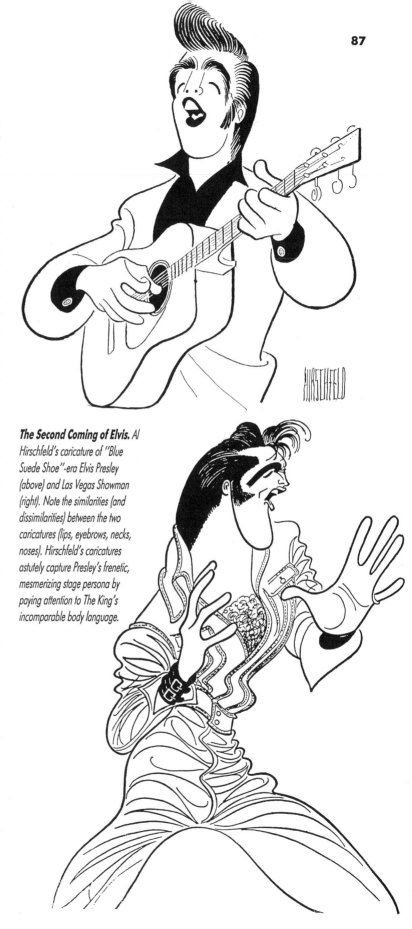

you feel him gyrating. Hirschfeld affords these mannerisms the same respect he pays to the characteristics of Astaire's and Presley's eyes, noses and mouths.

After all, mannerisms, body language and movements serve as further graphic clues which enable the reader to correctly perceive the caricature of Katharine Hepburn to be a caricature of Katharine Hepburn. You can't, for example, draw a terrific facial caricature of Katharine Hepburn and stick her on any interchangeable female body. Just as you study Hepburn's facial features (pronounced cheekbones, light eyes, taut smile), you study her from the neck down and caricature these elements as well.

"If you caricature John Wayne," says Jack Davis, "you think of his body, physique and build. People also have personalities in the way they walk—some people have a fruity walk, others have an athletic walk. You tell a story with your caricature, and if you're giving a body to the subject, you have to know what that figure looks like."

When it comes to analyzing bodies, Robert Grossman may see his subject as a kitchen appliance. "I determine," Grossman says, "if this person looks slender, if he looks like an animal, or even if he looks like a refrigerator. Drawing a caricature means generalizing that your subject is tall or boxy, a leading man or a squat old character, angular or bird-like."

After he is pleased with his facial caricature of a subject, Gerry Gersten refers to his *morgue* (a file of photographic images) for a body. "I have files," he says, "of all sorts of

The Second Coming of Elvis. Al Hirschfeld's caricature of "Blue Suede Shoe"-era Elvis Presley (above) and Las Vegas Showman (right). Note the similarities (and dissimilarities) between the two caricatures (lips, eyebrows, necks, noses). Hirschfeld's caricatures astutely capture Presley's frenetic, mesmerizing stage persona by paying attention to The King's incomparable body language.

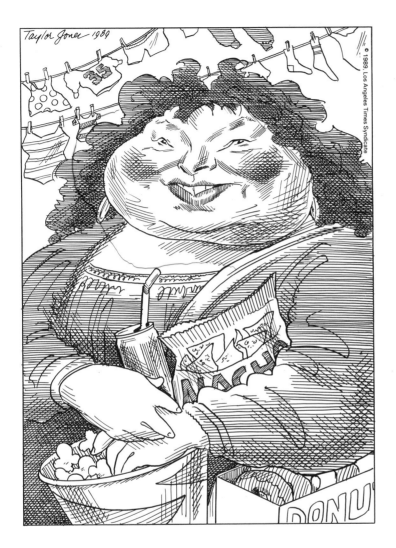

Taylor Jones 1989

© 1989 Los Angeles Times Syndicate

No Holds Barred. *Paying dubious homage to Leonardo DaVinci, Taylor Jones caricatures zaftig comedienne Roseanne Barr as the Mona Lisa.*

figures in many poses—sitting, standing, running, jumping. I pick a body that is appropriate to the person I am doing." Gersten may even try two or three different bodies in different positions to make sure they accurately jibe with his caricature.

Yet for some caricature subjects, the last thing they want lampooned are their bodies. Commissioned to do caricatures of stand-up comedi-

ans for a series of HBO video packages, Robert Risko managed to make Roseanne Barr threaten a lawsuit. "I caricatured Roseanne as a big, lovable doll," recalls Risko, "but her sister called and said if HBO used the caricature, Roseanne would sue. It was explained to me that Roseanne does not see herself as fat. Of all the stand-up comedians I had to draw, she and Sam Kinison, the two fatties, didn't want any kind of [caricature] representation on the video packaging and insisted instead on photographs of themselves."

Even Al Hirschfeld has managed to offend at least one of his subjects. Hired by CBS in the early 1960s to draw most of the network's stars for a major ad campaign, only one celebrity, Allen Funt, was infuriated by Hirschfeld's caricature of him. In fact, Funt was so outraged that he threatened to pull his hit show, "Candid Camera," off the air unless Hirschfeld redrew the caricature. Hirschfeld obliged with a considerably sweetened rendering of Funt.

And while celebrities have the power to disapprove of their own caricatures used for advertising purposes, they have no say in how a caricaturist portrays them in the general press. In the *New York Times,* you can caricature Barbra Streisand with a nose reaching from here to East Hampton, but there is very little she can do about it—unless, of course, she feels that the caricature has in some way libeled her. Happily, a free press insures that if so desired, caricaturists are allowed to overamplify facial features—provided we have paper big enough.

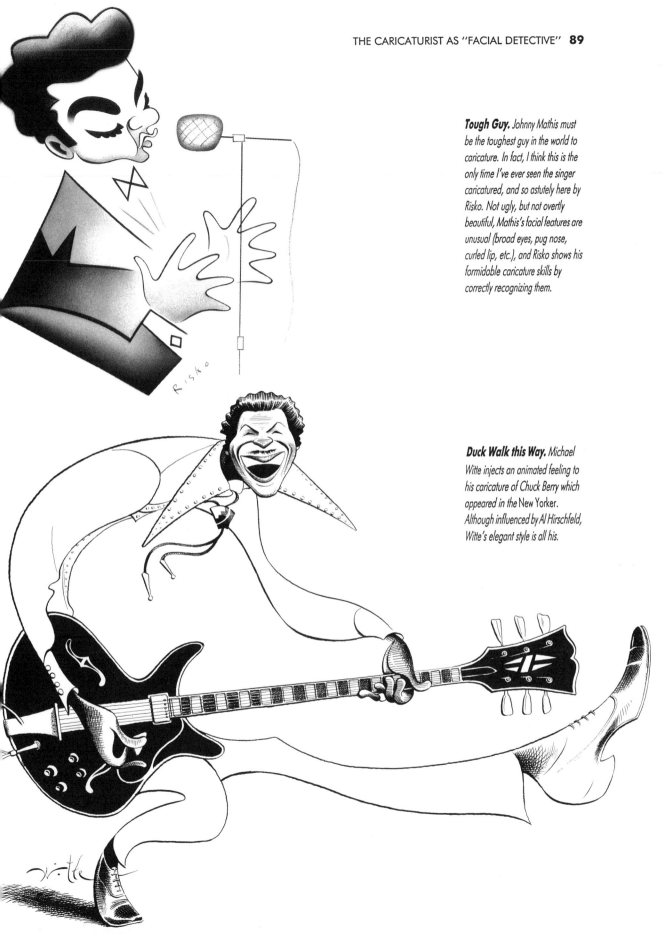

Tough Guy. *Johnny Mathis must be the toughest guy in the world to caricature. In fact, I think this is the only time I've ever seen the singer caricatured, and so astutely here by Risko. Not ugly, but not overtly beautiful, Mathis's facial features are unusual (broad eyes, pug nose, curled lip, etc.), and Risko shows his formidable caricature skills by correctly recognizing them.*

Duck Walk this Way. *Michael Witte injects an animated feeling to his caricature of Chuck Berry which appeared in the New Yorker. Although influenced by Al Hirschfeld, Witte's elegant style is all his.*

Preaching Politicos. *Robert Grossman airbrushes caricatures of (from left to right) Walter Mondale, Gary Hart, Jesse Jackson, Jimmy Carter and George McGovern for a 1984 cover of* New Republic. *Even though major portions of the subjects' heads and faces are obscured, Grossman is nonetheless able to convey believable, caricatured likenesses of the five.*

Preacher Politics

The Protestant tradition in the Democratic party

By WILLIAM LEE MILLER

Where's the Famous, Toothy Smile? *While editorial cartoonists almost always caricatured Jimmy Carter in the early days of his presidency flashing his famous set of choppers, toward the end of his term, caricaturists no longer focused on Carter's smile (which was disappearing anyway), but rather zeroed-in on his lips. And eleven years after he took office, Kate Salley Palmer caricatured Carter thusly.*

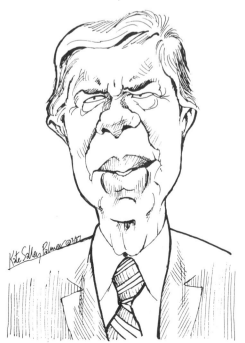

A Distorted View of Jackson. *Personally, I believe your subject determines to what degree you will exaggerate or distort him in caricature. In my estimation, Jesse Jackson's facial features are already distorted, so when I caricatured the politician here, I overamplified those features without getting excessive about it. Jackson's high forehead is made higher, his widely spaced eyes are spaced wider, his elongated neck is made longer.*

Giving Cosby the Twice Over.
Bill Cosby is caricatured by Rudy Cristiano on the right, and by Robert Risko on the left. What's interesting is that on an individual level, a reader would have no problem perceiving either caricature as one of Cosby. Only by comparing the two caricatures do you realize how differently Cristiano and Risko see Cosby. Note, for example, the variance in the way they caricature his nose, eyebrows and chin. However, they do agree on the general shape of Cosby's head, his large, bulging eyes, unmistakable lips and protruding cheekbones.

Doing the Right Caricature.
Spike Lee by Rick Tulka. Tulka draws the viewer into the caricature by overamplifying Lee's already buggy eyes. By understating Lee's clothing, Tulka insures that the viewer focuses in on his facial caricature.

Philistine. Rick Tulka takes his caricature of Phil Donahue a step further by interjecting some personality into his drawing. Not only does his drawing accurately lampoon Donahue's predominantly female audience, Tulka also astutely observes some subtleties—like the way the talk-show host gingerly holds a microphone and melodramatically gestures with his other hand. Such small touches give an added dimension to a caricature of a personality.

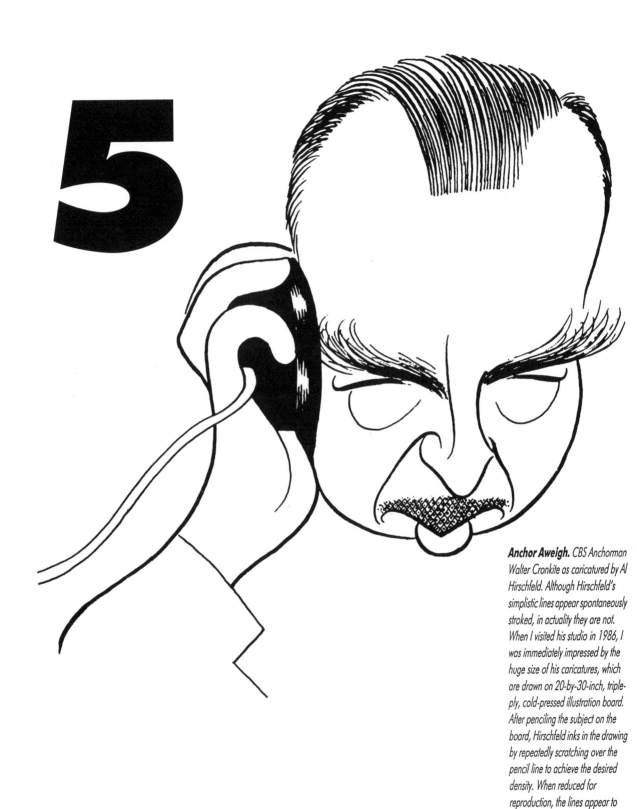

5

Anchor Aweigh. *CBS Anchorman Walter Cronkite as caricatured by Al Hirschfeld. Although Hirschfeld's simplistic lines appear spontaneously stroked, in actuality they are not. When I visited his studio in 1986, I was immediately impressed by the huge size of his caricatures, which are drawn on 20-by-30-inch, triple-ply, cold-pressed illustration board. After penciling the subject on the board, Hirschfeld inks in the drawing by repeatedly scratching over the pencil line to achieve the desired density. When reduced for reproduction, the lines appear to have been drawn spontaneously.*

CARICATURE REFERENCE

When the caricaturist sits down to render a caricature of a subject, he usually must refer to an actual, visual image (or images) of how that subject truly appears. Normally, this reference material consists of a photograph (or photographs) of the subject, but there are other forms of reference that the caricaturist can work from. Commonly referred to as *scrap*, good reference images are the backbone of any good caricature.

WORKING FROM PHOTOGRAPHS

Some caricaturists maintain huge filing cabinets in which photos and images of politicians, celebrities and world leaders are housed. While he worked as editorial and sports cartoonist for the *Los Angeles Herald-Examiner*, Karl Hubenthal kept an incredible morgue of photos on file in his well-equipped home studio. In spite of the mercurial nature of politics, Hubenthal was quickly able to pull out photos of newsmakers from his voluminous files to draw caricatures from.

Cartoonists who maintain offices at their newspapers are able to use the voluminous reference files in the newspaper's morgue and library. These morgues are so comprehensive that if a cartoonist is faced with the task of caricaturing a seemingly obscure bureaucrat like the Assistant Postmaster General, the newspaper may have eight,

nine, even ten photos (from as many angles) of the individual for the cartoonist to draw from.

Like Hubenthal, Taylor Jones understands the value of maintaining a bountiful studio morgue. "I'd really be in a serious problem," says Jones, "if I lost my picture files in a fire. I subscribe to a half-dozen news and picture magazines, but I may even pass a newsstand and notice a good photo on the cover of *Vanity Fair*, so I'll buy it. Then every Sunday, I tear out all the magazine photos of potential caricature subjects and file them alphabetically. I probably have 40,000 to 80,000 photos. But every once in a while, I'm assigned to do a caricature of somebody I don't have a photograph of."

Still, few caricaturists must saddle themselves with the excruciating, time-consuming responsibility of sustaining their own reference-photo morgue. Happily, when an art director or editor gives an assignment to a caricaturist, he is also obliged to supply the appropriate scrap to the caricaturist. And from the caricaturist's point of view, the more visual reference he can be supplied with, the better.

"I don't have time to go out and secure scrap," says David Levine, "so I am provided with this material by the magazine I happen to be drawing for. Hopefully, I have worked long enough for [an art director or editor] that they know what kind of scrap I need. What I need are several shots of the sub-

Straight Up. *Philip Burke caricatures overnight pop sensation Paula Abdul. Burke says that when given a caricature assignment, he tries to find as much as he can visually or otherwise about the subject. "I'll look through my magazines, and the art director will send me photos," he says. "I also try to get them on videotape, and with an actor or a musician, I can usually get them on a movie or MTV."*

Katharine the Great. *Sam Norkin caricatures Katharine Hepburn as she appeared in the play A Matter of Gravity.*

ject. There are, after all, times when a subject's coloration is changed by whether they were photographed in natural light or with a flashbulb— that can change everything. Ideally, I need a certain kind of rather bland, but somewhat lit photograph. But I'll work from anything.''

''I demand from the client that they furnish me with as much scrap as possible,'' says Gerry Gersten. ''Before I start drawing, I am surrounded by a surplus of research, all of which you don't use, but it helps you get caught up in the mode of the individual you are caricaturing. Most of it is subconscious, but you develop a feeling for that person. For me, the abundance of research is essential.''

''A caricaturist needs to work from good photos,'' says Jack Davis. ''I don't think you can look at a profile photograph of a subject and then be able to get away with a three-fourths view of him—it's impossible. You can get away with it, but the caricaturist needs really good photos. When I look at the photos, expression is the most important thing to me—whether you're trying to draw the subject angry, happy, or whatever, I look at that first. Then I like to see cast shadows in the photos—a flashbulb photo of a subject isn't what I'm really looking for. But since I don't keep files of reference photos here in the studio, I have to depend on what scrap my client sends to me.''

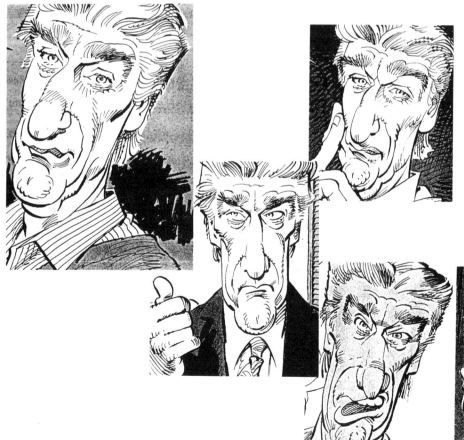

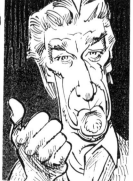

Mugging It Up. *If it's difficult enough to caricature a subject once, Mort Drucker must capture a celebrity ten, fifteen, even twenty times within a MAD movie or TV satire. Here are five examples of Drucker's caricatures of actor Richard Mulligan which appeared in the magazine's parody of the TV sitcom "Empty Nest." Drucker studies how the dominant features change in key expressions, which helps him maintain a consistency in the likenesses.*

For the caricaturist, it is rare that a single photograph of a subject will suffice (Sam Viviano will hold as many as ten photos in his left hand while he draws with his right). The more photos the caricaturist has to work from, the more things revealed about the subject. A head-on photo might lead the caricaturist to believe that the subject has a thin nose, when a three-fourths view photo might show that it is narrow but also beak-like and quite prominent. Furthermore, one photo might convince the caricaturist that the subject's mouth is quite average, while another shot might expose the subject's rather ample lips.

Multitudinous scrap and reference photos are essential if the caricaturist is to draw a subject in a number of poses. It would be almost impossible for Mort Drucker to effectively caricature the same subject over and over in one of his trademark MAD movie satires if he were not provided with a fair amount of scrap.

In *The Art of Caricature*, by Nick Meglin (Watson-Guptill, 1981), Drucker states that he's "always surprised to see how many photographs of people don't actually look like them. In a collection of movie stills from any one film, you're sure to find several shots of an individual whom had you not known who it was, you wouldn't be able to recognize. If I drew my characters that way — staying completely true to the reference material — it would be thought to be a bad job. That's why I try not to depend solely on photos. Being an accurate copier doesn't insure good likeness. A caricaturist, like a portrait artist, deals not with

Whole Lotta Rockin' Going On. *Billy Idol, Elvis Costello and Bob Dylan are captured by Sam Viviano. Viviano worked from photos when caricaturing the rockers.*

No Exaggeration Here. *In this preliminary pencil drawing for a* MAD *spoof of* Gone with the Wind, *Jack Davis draws relatively straight depictions of the movie stars but interjects caricatured qualities to their bodies, gestures and mannerisms. "What I do," says Davis, "is really take a photograph of a subject and almost copy it. Then I put a body on it or put the subject into a certain situation."*

reality, but with images reduced to line and/or tone on a two-dimensional surface.''

Faced with the task of caricaturing Jay Leno not once, but fourteen times in his book *Headlines* (1989) and the sequel, *More Headlines* (1990), I was provided with thirty-five color snapshots of Leno by Warner Books. Better yet, Leno really mugged it up for the camera by giving me every facial expression I could think of (and some I couldn't). However, I didn't rely on these flat, two-dimensional photographs of Leno. While they were important reference elements, I found my videotape of Leno to be particularly useful. Videotape of Leno's ''Tonight Show'' monologues, ''Late Night with David Letterman'' appearances, and even his Doritos commercials, gave me insight into the comedian's expressions, mannerisms, gestures and personality.

TV Quickie. *I was watching ''The Arsenio Hall Show'' and couldn't resist caricaturing the unique-looking host. Drawn with a ballpoint pen, this caricature took about three minutes to create. When I briskly draw caricatures, my snap judgments are usually correct.*

Bully! *Teddy Roosevelt is caricatured by Bill Plympton from one of the few photos taken of the rough-riding president.*

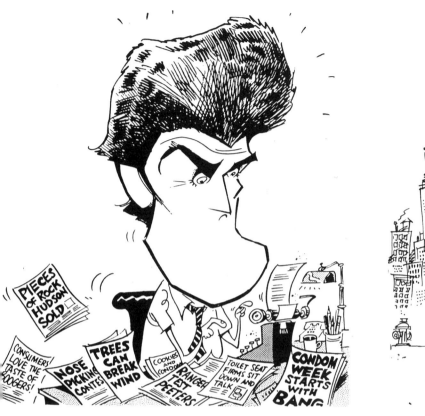

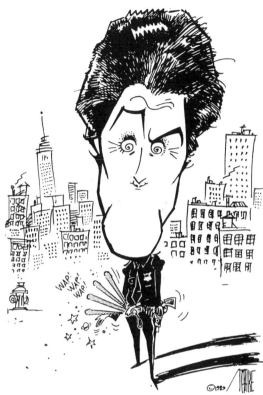

Chin Up. Warner Books called on me in 1989 to illustrate what became Jay Leno's best-selling book, Headlines. Working from snapshots and video of Jay, I caricatured him fourteen times for the chapter-divider pages. I was given a tremendous amount of creative freedom on the project, and Leno's only concern was that I not draw his chin "too gigantic."

98

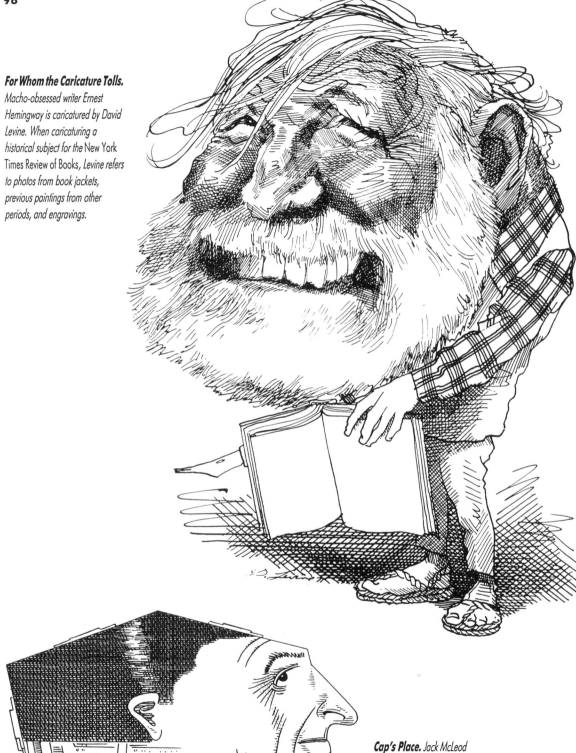

For Whom the Caricature Tolls.
Macho-obsessed writer Ernest
Hemingway is caricatured by David
Levine. When caricaturing a
historical subject for the New York
Times Review of Books, Levine refers
to photos from book jackets,
previous paintings from other
periods, and engravings.

Cap's Place. Jack McLeod
caricatures Reagan-era Secretary of
Defense Caspar Weinberger in the
shape of the Pentagon building itself.

WORKING FROM VIDEO

Videotape can provide the caricaturist with an abundance of diverse imagery of his subject. Unlike reference photos, which yield frozen views of a subject, videotape gives the caricaturist a sequential look at the person he is to draw—yet the tape can be frozen at the caricaturist's discretion. In these technological times, videotape is an indispensable tool for the contemporary caricaturist.

For Bill Plympton, the advent of videotape meant a change in his working habits. "Like most caricaturists," recalls Plympton, "I used to work from photographs in *Time*, *Newsweek* and *Life*, but I found that unsatisfactory for a number of reasons. For one, these magazines would come out two or three weeks after the [caricature] subject became famous. Like if someone was elected president of Australia, you wouldn't be able to find any pictures of him, and you'd have to wait two weeks for a photo of him to appear in *Time*. But I found that if I watched ABC News, they would have pictures immediately, so I would tape their broadcast and freeze frame the pose I liked best.

"Working from video is also helpful," Plympton continues, "because print photos are usually quite bad, and they usually present a pose that you don't like or that doesn't show the subject in a truly caricaturable pose. You can scan the video for a pose that shows potential for exaggeration and distortion—a three-fourths angle, properly lighted, and

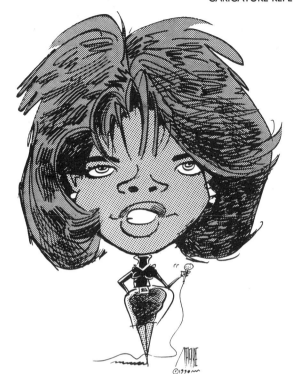

New and Improved Oprah.
Sounds like a new product from Procter & Gamble. Actually, this is my caricature of the considerably slimmed down Oprah Winfrey. When drawing this caricature, I drew directly from broadcast television (rather than freeze framing videotape). Each time I caught a glimpse of Winfrey, I'd jot down one of her facial features (widely spaced "bedroom" eyes, broad nose, full lips). When I use TV as a reference tool, the line in my caricatures always has a more spontaneous look— something that appeals to me.

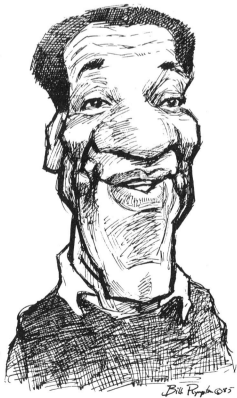

Bill by Bill. *TV dad Bill Cosby as caricatured by Bill Plympton. Plympton enjoys caricaturing his subjects from TV. "It's easy to understand the structure of their face when they turn their head."*

Freezing Barbara. *Luckily for me, I had some videotape of Barbara Walters, which I freeze framed in order to caricature her.*

Small Eyes, Big Everything Else. *While watching comedian Garry Shandling on "The Tonight Show," I became intrigued by his face and began sketching. I started by drawing his rather hefty nose. Next, I studied Shandling's lips, which he doesn't mind admitting are "really big." But as I watched Shandling, I noticed something odd happened when he smiled: his rabbit teeth were exposed. I felt his eyes could be represented by mere, small dots, but his eyebrows seemed to constantly appear worried, thus causing crow's feet and wrinkles on his forehead. There's only one word to describe Shandling's hair: big. Put it all together and you have a pretty decent caricature of a very refreshing comic.*

with good cast shadows—shadows are wonderful because they show the contour of the subject's face, and are wonderful to caricature, too.''

During the mid 1980s when his timely newsmaker caricatures were syndicated by Universal Press Syndicate, working from video made Plympton's job 100 percent easier. ''With video, I could at least sketch and pencil out the character in rough form. Also, I found that when the subject was moving, it became easier to recognize the structure of his face because you see his head turn. Even when I've had problems caricaturing somebody like Jack Nicholson or Warren Beatty from photographs, I've gone out and rented one of their movies.''

Though he usually works from photographs, David Levine has used video as reference. ''I drew a caricature of pianist Vladimir Horowitz from video,'' Levine says, ''because I realized there were certain moments captured on video that aren't going to show up in a still photograph.''

For myself, video serves as an instantaneous, time-saving form of reference. Even if I am able to scrape up only one second of videotape on a given caricature subject, that one second is equivalent to thirty individual pictures (the most comprehensive morgue file might reward you with ten photos of that subject). And since I possess a library of more than 1,200 hours of videotape, I am usually able to find a video snippet of almost any subject I am asked to caricature.

Although this video library is not nearly as well documented or item-

ized as I would like it to be, it is relatively easy for me to access the pertinent video I seek. For example, I was recently faced with the task of caricaturing Barbara Walters, and since the client provided me with no scrap, I scoured my two hundred tapes. Sure enough, tape number sixty-seven contained a 1987 "20/20" report on the popularity of Mad Balls, and sure enough, the spot was introduced by Walters. (Mad Balls, popularized in 1987, were toy balls made of foam. The brightly colored balls sported particularly gross facial features. Kids, therefore, loved them.) If it weren't for video's phenomenal accessibility, I would have had to make a run to the library and hope that I could find at least one grainy photo of Walters in a dog-eared, back issue of *People*.

WORKING FROM REAL LIFE

While he generally draws his caricatures from videotape and television, Gerald Scarfe says "the best thing of all is to see your subjects themselves. *Time* sent me to travel with Nixon in 1972, and there was nothing like being there and watching the way he walks and stoops and sits down and talks."

Nevertheless, Scarfe admits that caricaturing his subjects from real life can be an intimidating experience. "I don't like to sit down in front of my subjects and draw them," he admits, "because I think I might pull my punches in fear that the subject might look at my caricature afterwards. Usually, a caricature is drawn in privacy, so there is no

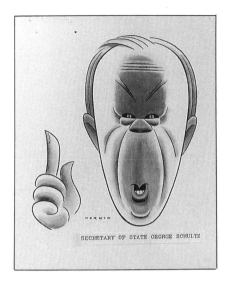

SECRETARY OF STATE GEORGE SCHULTZ

By George. *Though George Schultz isn't caricatured that often, Norkin's rendition of the Reagan-era Secretary of State is the best I've seen. Wonderfully fun. Note the decisions that Norkin has made about Schultz's facial features: eyes beady and close together, wide space between nose and upper lip, a head shaped like a gravity-defying ostrich egg.*

Lively Politicos. *Whenever possible, Gerald Scarfe enjoys caricaturing his subjects from real life. Here Scarfe draws (from left to right) Lyndon Johnson, Robert Kennedy, and three studies of Richard Nixon. Scarfe drew the presidents during their presidential campaigns on assignments for* Time *magazine.*

Live from New York. Rick Tulka finds that New York City subway passengers make excellent caricature subjects. Caricaturing from real life is a wonderful way to understand the subtleties of such things as facial features, physical characteristics, mannerisms, body language and anatomy.

apprehension about the subject looking at it in print eventually.''

Although face-to-face encounters between caricaturist and celebrity subject are rare, they certainly do occur. Every four years, many of the nation's editorial cartoonists descend on the political conventions to draw their graphic impressions of in-the-trenches party politics. For most of the cartoonists, the conventions afford the dubious opportunity of drawing from real life the politicians that they have been drawing for years from wire photos and TV news broadcasts. But if you draw George Bush day in and day out, chances are slim that you'll gain some new visual insight into the man as you glimpse his limousine careening through a hotel's subterranean garage.

Nevertheless, if the cartoonist is fortunate enough to get close to his celebrity subject, drawing from real life can be a revealing experience. While a student at the University of Southern California in 1977, I somehow managed to convince university officials to let me tag along with the working press assigned to cover former President Gerald Ford's college lecture tour. While I had drawn Ford from photographs countless times, I was amazed at the facial details revealed in the live encounters with him.

In fact, if anything, I found myself disoriented by the profound details suddenly apparent in Ford's face. Six feet away from him, I could see exactly how his nose was shaped, how his lips were formed, how his upper teeth were exposed when he laughed. It was almost too much detail (couldn't see the forest for the trees?).

His features were no longer the generalized graphic symbols we cartoonists had been promoting, rather I was made aware of Ford's subtleties—subtleties that couldn't have been communicated in the halftoned photos or the cathode-

ray imagery that I had been accustomed to seeing. Suddenly, all my previous caricatures of Ford were suspect, but all my subsequent caricatures of him took into account the face-to-face lessons I learned in 1977.

I had a similar revelation in 1978 with then California governor and presidential candidate Jerry Brown. I was picking up a fellow cartoonist (Paul Duginski, now art director of the *Sacramento Bee*) at the Los Angeles International Airport, and we happened to notice that Brown was arriving at the adjacent gate. Being stupid college kids, we decided to force ourselves on Brown (this, no doubt, must have delighted his entourage of Secret Servicemen). Brown seemed rather startled by our *chutzpah*, but shook our hands and exchanged a few pleasantries.

Brown probably wondered why I was staring so intently at him. Up close, I had noticed that most of Brown's facial features jibed with how I had always caricatured them (large nose, extremely dark eyebrows, pouty mouth, graying temples), but I realized that I was off the mark on other features. The top of his head, for example, seemed more rounded than the flat way I had been caricaturing it, and his chin was almost nonexistent. I had always known that Brown wasn't the tallest of men, but I doubt he stood taller than my nose (I'm 6'2"). With such new truths revealed to me, I couldn't wait for the next opportunity to draw my new and improved caricature of Jerry Brown — even if it would be rounder, shorter and chinless.

Within the context of a party cari-

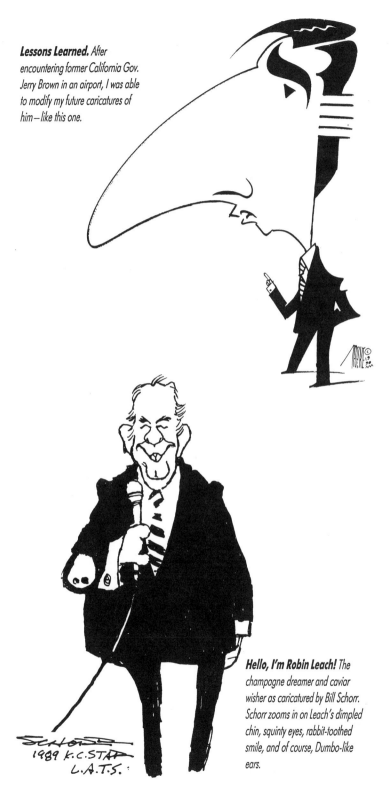

Lessons Learned. *After encountering former California Gov. Jerry Brown in an airport, I was able to modify my future caricatures of him — like this one.*

Hello, I'm Robin Leach! *The champagne dreamer and caviar wisher as caricatured by Bill Schorr. Schorr zooms in on Leach's dimpled chin, squinty eyes, rabbit-toothed smile, and of course, Dumbo-like ears.*

Anything for a Rating Point. My caricature of "shock" TV talk- show host Geraldo Rivera. Rarely do I rely on my own assessment of whether or not I have accurately caricatured a subject. After I feel comfortable with my sketch, I'll fax it to a friend or two for their input. If they fax the caricature back with a note saying, "I'd know him in a second—it's Burt Reynolds," it's back to the drawing board for me.

cature environment (covered in greater detail on pages 40-43), the caricaturist almost aways draws his subjects from real life. But in this situation, the caricaturist is afforded an inordinate amount of dominion. If the caricaturist cannot control the content of his photographic or video reference, he can pose his subject to reveal the ideal angle.

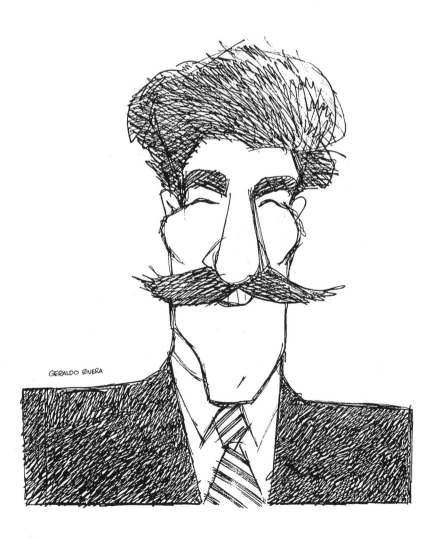

GERALDO RIVERA

WORKING FROM MEMORY

For the caricaturist blessed with a keen observing eye and acute mental recall, the ability to draw from memory is a rare but highly useful faculty. Memory, after all, is a reference tool which is self-contained in any caricaturist's gray matter (rather than filing cabinet). And if the brain cells are firing properly, caricaturing a subject from memory can be a truly enlightened, expressionistic experience.

If I am assigned to do a caricature of Johnny Carson, I already have a number of preconceived pictures in my mind. Not only do I recall Carson's facial characteristics (button nose, prominent ears, broad smirk, light eyes), but I also see his mannerisms, gestures, body language and personality (hands behind his back for the monologue, drumming pencils at his desk, padded sportcoat shoulders, his various tics). I also have an idea for Carson's color (white hair against a tan face, bright gray-blue eyes, a light blue, checkered sportcoat, etc.) and even the "Tonight Show" environment.

Without pulling out a single two-dimensional photograph or videotape, I have a solid mental infrastructure of Carson. I may in fact pull out a videotape of Carson, but I would do so only to validate or minimally amend my preconceived mental image of him.

There are few celebrity subjects for whom I do not have a pretty good visual infrastructure (I do, after all, read those tabloids while I'm waiting to pay for my produce).

Happily, I seem to have a strong observational eye, a photographic memory, if you will. If I see it, I tend to store it and am then able to process it if and when I must. I may not remember where I left my car keys, but I have no problem remembering what an obscure celebrity like Don Rickles looks like.

Nonetheless, I know few other cartoonists or caricaturists who can reliably depend on their memories of the subjects they are assigned to caricature, and I doubt one can *learn* to draw from memory—it seems to be a talent that you're born with, not one that is easily acquired.

When a caricature assignment crosses Bruce Stark's desk, there's a very good chance that he already knows his subject. "Nine times out of ten," he points out, "I've seen the person on TV or in the movies. When you see so many pictures of that person, you get a strong feel for them because you have seen them from many different angles. I caricature quite a bit from memory because you just can't do it all from photographs. Depending on your recall of how that person acts, talks, walks and so forth, you put those elements together and you have a caricature. A caricaturist must have good visual recall.

"I have a vast file of photos," says Stark, "or sometimes a client will send me photos of a subject. But often these photos aren't what you'd like, so you have to reach back into your memory of what you believe this subject to look like."

The Living Presidents. *When I caricatured our five living chief execs in 1990, I did so entirely from memory. After all, over the years I've caricatured Richard Nixon, Gerald Ford, Jimmy Carter, Ronald Reagan and George Bush countless times, and these guys would be pretty hard to forget.*

Faces in the Crowd. *These sketches show how Kate Salley Palmer develops her caricatures, whether drawing from life or television. By sketching from a number of different angles, Palmer is able to better understand individual facial features by recognizing their shape, degree of prominence, etc. The sketches of New York Governor Mario Cuomo (on the far and upper*

left) were drawn from life, as were those below Cuomo of columnist Carl Rowan. The central sketches of Fawn Hall, Oliver North, and two of National Security Adviser Robert McFarland were drawn from television. Washington Post editor Meg Greenfield (lower right), and political historian Arthur Schlesinger (upper right) are caricatured from life in three-fourths and side views.

Rick Meyerowitz is another caricaturist who claims to "have very good visual recall," but it is his memories of past caricatures of a given subject that Meyerowitz draws from. "If I caricature someone two or three times," Meyerowitz explains, "I can call that up. I can still caricature a Ronald Reagan with a pretty fair amount of detail, but the danger is that you can run into formula—that's something that editorial cartoonists do. Photos help refresh the cartoonist's memory. I

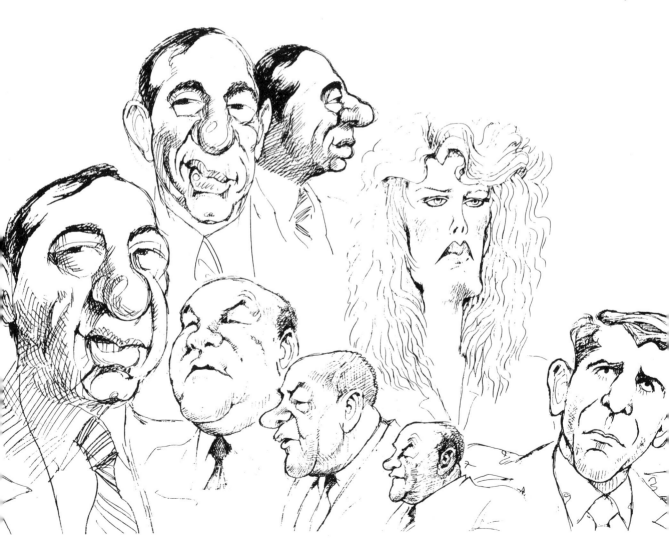

might use a scrap photo to refresh my memory, but I wouldn't copy off of it—that's not the way I work."

Utilizing memory (or at least experimenting with it) to create caricature seems to be regrettably rare. In fact, if a caricaturist were assigned to caricature Joan Rivers, most would assumptively initiate the project by studying photos or videotape of the comedienne. The last thing on their minds would be to scour the nooks and crannies of their cerebral noodle for any and all

visual data on Rivers—at best, they might mentally determine that Rivers will be either an easy or difficult caricature.

But if the caricaturist trusts his ability to accurately perceive Rivers's caricaturable features in a flat photo, then perhaps his pre-existing memories of these features are just as astute. Blindly "doodling out" introspective memories can be a surprisingly revealing (and potentially accurate) experience for any caricaturist.

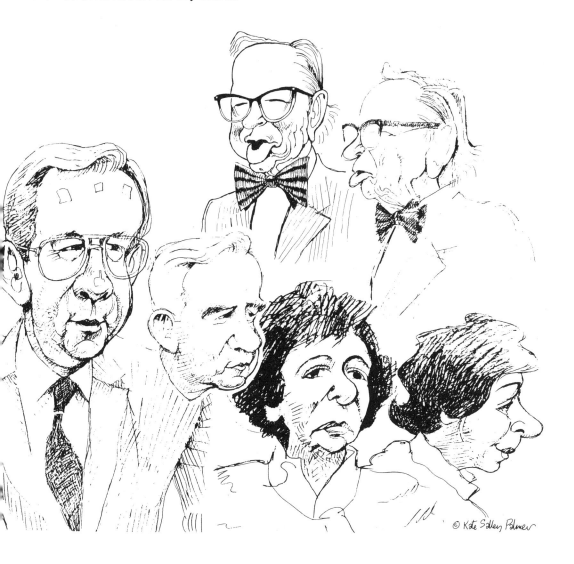

© Kate Salley Palmer

Down by the Rivers Side. *Sam Viviano's caricature of comedienne and talk-show host Joan Rivers. "More often than not," says Viviano, "I end up caricaturing people into a context, so I give them certain expressions because they are reacting to something."*

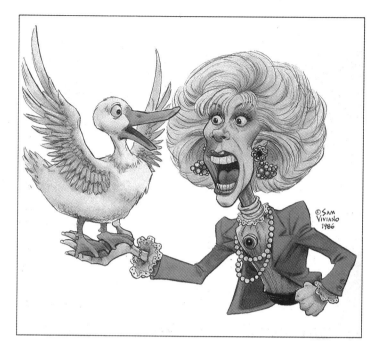

Get a Grip, Ed. *Rick Meyerowitz caricatures Ed McMahon wrapping his pudgy hands around Johnny Carson's throat. While Meyerowitz has "good visual recall," he may use photos when creating a caricature of a subject because they "refresh" his memory.*

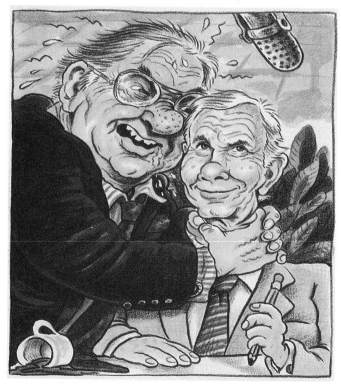

Helter Skelter. *Almost a walking, talking (make that incoherent, babbling) caricature himself, Charles Manson is caricatured by Marcia Staimer in* The Washingtonian *magazine.*

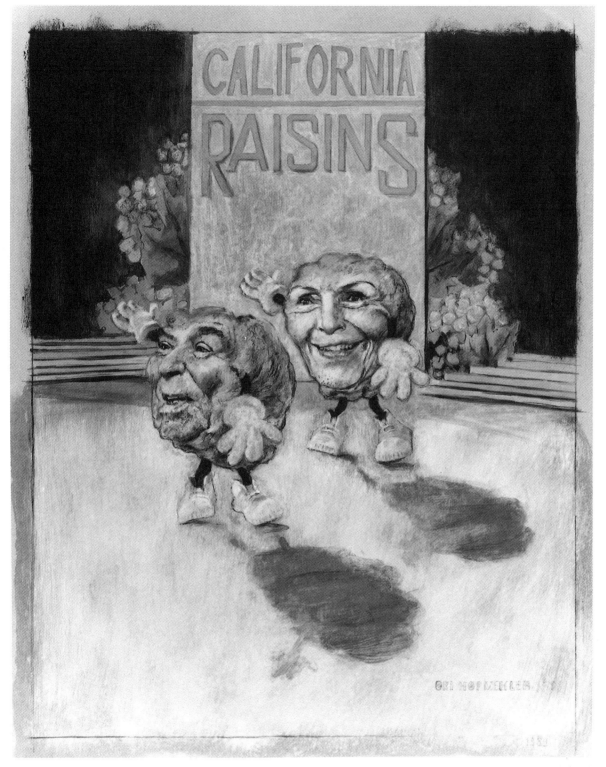

The Grapes of Wrath. *They're plump, they're purple, and they're wrinkly—sounds like the California Reagans to me. Ron and Nancy by Ori Hofmekler.*

Great Balls of Fire. *Steve Haefele caricatures Jerry Lee Lewis meeting his future wife in a schoolyard.*

One More Celebrity and We're in Violation of the Fire Code. *Al Evcimen paints caricatures of media stars. Top row: Bruce Springsteen, Bette Midler, Paul Newman, Michael Douglas, Michael J. Fox, ALF. Second row: Madonna, Jack Nicholson, Danny DeVito, Eddie Murphy. Third row: Bruce Willis, Bill Cosby, Vanna White, David Letterman, Cher. Fourth row: Paul Hogan, Michael Jackson, Sylvester Stallone.*

We Prefer His McDonald's Jingles. *Pop singer Barry Manilow is caricatured by Rudy Cristiano. Note Cristiano's clever touch in the lower right—Manilow's jacket lapel is a piano keyboard.*

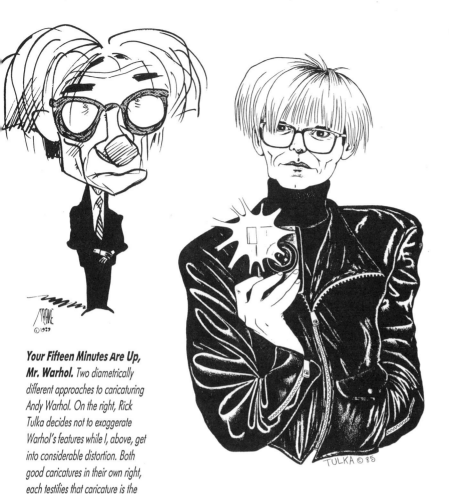

Your Fifteen Minutes Are Up, Mr. Warhol. *Two diametrically different approaches to caricaturing Andy Warhol. On the right, Rick Tulka decides not to exaggerate Warhol's features while I, above, get into considerable distortion. Both good caricatures in their own right, each testifies that caricature is the result of a series of subjective decisions made by the individual caricaturist.*

Crowded Conditions.
"Unfortunately," says Sam Viviano, "I've gotten a reputation as someone who can do crowd scenes." Here, Viviano caricatures some of 1985's in-crowd. Pictured from the top are (1) Tom Selleck, (2) David Hasselhoff, (3) Mr. T, (4) Emanuel Lewis, (5) Harrison Ford, (6) John Stamos, (7) Valerie Bertinelli, (8) Heather Locklear, (9) Nancy McKeon, (10) Gary Coleman, (11) Ricky Schroeder, (12) Clara Peller, (13) E.T.

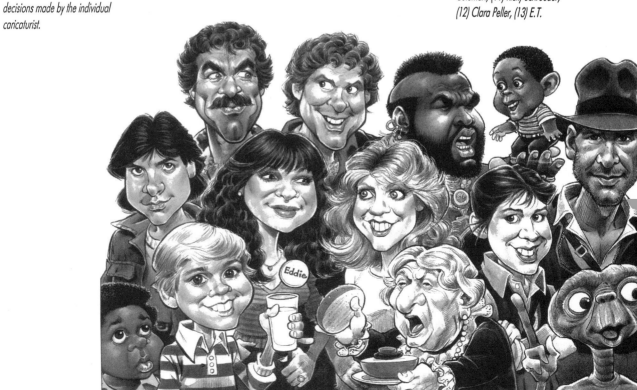

ARTISTS' PROFILES

STEVE BRODNER

Born: *October 19, 1954*
Birthplace: *Brooklyn, NY*
College: *Cooper Union*
Degree: *Bachelor of Fine Arts*
Began Professional Career: *1972*
Books Illustrated: *Fold 'N' Tuck*
 (Doubleday, 1990)

From *Playboy* to *Harper's, Sports Illustrated* to *Esquire*, you'll find Brodner's inventive, rubber-faced caricatures. Before becoming known for his magazine caricature and humorous illustration, Brodner worked as an editorial cartoonist. For the aspiring caricaturist, Brodner suggests that "you must know yourself in life—and in art."

On Caricature As Fine Art:

"The whole design of the [caricature] is important. I'm not just interested in the figure, but in the whole square patch on the page as an art experience. I'm very self-conscious about sounding pretentious about how serious this should be taken, but I consider these caricatures to be paintings on some level. I try to do many things at once with the caricature."

On Creating Action:

"I'm always trying to create action in the caricature so that one's eye gets taken around the painting the way you would view a real fine-art painting. The same rules that make painting exciting must apply to any visual medium, caricature included."

On Influences:

"Hirschfeld, Levine and Steadman have had the most impact on caricature in the last part of the twentieth century, at least on me. I'm even influenced by Cezanne and Matisse. Steadman advised me not to look at other caricaturists, but to look at real artists in museums."

PHILIP BURKE

Born: *November 27, 1956*
Birthplace: *Buffalo, NY*
College: *None*
Began Professional Career: *1977*

"When David Levine told me that painting and caricature will never mix," says Philip Burke, "I had a goal." Indeed, Burke has proven Levine wrong. Burke's highly unique caricatures have appeared in every major American magazine from *Time* to *Newsweek*, *Rolling Stone* to *Esquire*. Burke's advice to the aspiring caricaturist is to "draw ten times more than anybody else you know."

On "Getting Psyched":

"I have to stretch my own canvas because they don't sell them that big (five to six feet tall). When I stretch a big canvas, I get really psyched when I do it—you get closer to it."

On Blurring Distinctions:

"When I first started caricaturing, I made a determination to try and blur the distinction between commercial and fine art."

On Response to His Work:

"After I did his caricature, Peter Uberroth sent me a letter saying 'Nice job, keep up the good work,' but such response is rare."

JACK DAVIS

Born: *December 2, 1924*
Birthplace: *Atlanta, GA*
College: *University of Georgia at Athens*
Athens Students League
Began Professional Career: *1935*
Books Illustrated: *The Art of Jack Davis*
 (Stabur Press, 1987); *The Art of
 Humorous Illustration*, by Nick Meglin
 (Watson-Guptill, 1973); *The No-Name
 Man of the Mountain* (Harcourt Brace
 Jovanovich, 1964)

Perhaps best known for his regular MAD magazine contributions, Jack Davis is also one of the country's most active advertising cartoonists. Davis's doodles have been used to sell everything from Jell-O to Mennen After Shave, A-1 Steak Sauce to Michelob Light, Bic Pens to Pepto Bismol. Davis's advice to aspiring caricaturists is to ''enjoy your work. Be influenced by others, but be yourself.''

On Big Feet:

''When I do a caricature, I really don't distort facial features but I try to draw them more the way they look — but I will give the subject big feet or big hands.''

On His Legendary Drawing Speed:

'' With MAD, I work fast and can be very, very loose. In fact, sometimes I prefer how my rough pencil drawings look in comparison to the final, penned drawing.''

On Favorite Celebrity Subjects:

''I always enjoyed caricaturing Bob Hope, and presidents Ford and Carter. I remember when Carter changed the part in his hair and it threw all us cartoonists off!''

GERRY GERSTEN

Born: *October 17, 1927*
Birthplace: *New York, NY*
College: *Cooper Union*
Degree: *Bachelor of Fine Arts
 (Advertising Art/Fine Arts)*
Began Professional Career: *1958*
Books Illustrated: *Guys and Dolls*
 (Franklin Library, 1979); *Round Up*
 (Franklin Library, 1977); *How to Be a
 Jewish Mother* (Price Stern Sloan,
 1964)

While he is probably best known for his caricatures which illustrate the Quality Paperback Book Club ads, Gerry Gersten's work can be found everywhere. *Time, Esquire, Newsweek, Life, Money* and GQ have used Gersten's astute, highly stylized caricatures. For the aspiring caricaturist, Gersten insists that he "must be curious and observant."

On His First Caricature:

"I did bandleader Mitch Miller a long time ago—first caricature. By today's standards, it was a little stiff. But I was intrigued by how it looked like him. The experience of a one-to-one relationship with a celebrity was exciting. When you do a caricature, you have a contact with that celebrity even though they don't know it."

On Old Friends:

"After you have done a caricature of some prominent living person, like Reagan or Bush, and you see them on television, my immediate reaction is 'Hey, there's my old friend!'

That is, in the process of doing the caricature, emotion is an integral part of the process—you actually feel you have drawn somebody that you now know as well as any one of your friends, with the same intimacy."

On Whether Caricature Can Be Taught:

"I think you can learn from a caricature class certain ways to focus, to concentrate on things the masters have discovered, but you have to be a damn good drawer of anything to be a good caricaturist. The drawing is as important as the likeness. Caricature can be taught, but the sensitivities cannot. It has to be part of your psyche—of who you are."

ROBERT GROSSMAN

Born: *March 1, 1940*
Birthplace: *New York, NY*
College: *Yale University*
Degree: *Bachelor of Arts in Fine Art*
Began Professional Career: *1961*
Books Illustrated: *What Can a Hippopotamus Be?* (Parents, 1975)

The question isn't, Where have Robert Grossman's caricatures appeared, it's, Where haven't they. From *Time* to *Newsweek*, *Esquire* to *Sports Illustrated*, Grossman's lush, airbrushed caricatures exude stylistic originality. Grossman's advice to aspiring caricaturists (although somewhat redundant) is, "Go! Go! Go!"

On the Zoo:

"You can learn more about caricature by doing drawings at the zoo than reading twenty books about it."

On Cheap Billionaires:

"On the whole, most people like the attention of being caricatured. I've done a lot of caricatures for business magazines where the subject may be a millionaire or a billionaire. They may want the original drawing, but they never expect to pay for it."

On Laurels:

"My quintessential caricature is the one that I'm going to do today. There may be a way of resting on one's laurels, but I haven't figured that out yet."

AL HIRSCHFELD

Born: *June 21, 1903*
Birthplace: *St. Louis, MO*
College: *None*
Began Professional Career: *1923*
Books Illustrated: *The World of Hirschfeld* (Abrams, 1968); *Show Business Is No Business* (De Capo Press, 1979); *The Lively Years* (The Association Press, 1973)

For many, Hirschfeld *is* caricature. His highly stylized theatrical caricatures appear regularly in the *New York Times*, and his work has been published in virtually every major American magazine from *Time* to *Sports Illustrated*, *TV Guide* to *Playboy*. In 1945, Hirschfeld began cleverly weaving the name of his daughter, Nina, into his caricatures. Lithographs, pen-and-ink originals, and etchings of Hirschfeld caricatures are represented exclusively by The Margo Feiden Galleries of New York City.

On Personality:

"The enigma of personality is elusive. The adventure of translating personality into graphic symbols defies classification. I consider a successful likeness has been achieved when the subject begins to look like the drawing rather than the other way around."

On "The Medium":

"Communication in caricature must tell its story in abstract line. The limitation of the medium is an integral part of the message. Marshall McLuhan's succinct philosophy, 'The medium is the message,' is an apt description of caricature."

On Freaks and Lunatics:

"In my time, artists, writers and poets were treated with reverence and their opinions were highly valued. During the twenties and thirties, before TV and predigested thought, people took artists' thoughts seriously on social matters, economics and the joy of art and living. But today, unless you make money, you're not respected. Now the quotes you read are from businessmen, and artists are thought of as untrustworthy freaks and lunatics."

TAYLOR JONES

Born: *December 10, 1952*
Birthplace: *Mineola, NY*
College: *Cornell College (Mt. Vernon, IA) Political Science*
Degree: *Bachelor of Special Studies, Political Science*
Began Professional Career: *1974*
Books Illustrated: *Add-Verse to Presidents* (Dembner Books, 1982); *How to Talk Baseball* (Dembner Books, 1983); *How to Talk Football* (Dembner Books, 1983)

Perhaps best known for his timely newsmaker caricatures which are distributed by the Los Angeles Times Syndicate, Taylor Jones's work has also appeared in *New Republic, U.S. News & World Report* and *El Nuevo Día,* a daily Puerto Rican newspaper.

On Caricaturing Men and Women:

"It's not at all easier to caricature men as opposed to women. It depends on how they look. With politicians, it doesn't matter. Indira Ghandi was just as easy as Richard Nixon."

On Dan Quayle:

"Someone who is deceptively easy to caricature is Dan Quayle. There's something in his eyes which is so amusing. Mark Shields called him a 'deer in headlights.' There is something about Quayle's hair and mouth that is just perfect for caricature."

On Being Fooled:

"Some caricature subjects are a surprise. I can always look at a face and have a pretty good idea of what I'm going to do with the caricature and decide 'this person will be easy' or 'this person won't.' Every once in a while, I'm fooled, and someone you think would be easy proves to be very difficult."

DAVID LEVINE

Born: *December 12, 1920*
Birthplace: *Brooklyn, NY*
College: *Stella Elkins School of Fine Art of Temple University*
Degrees: *Bachelor of Fine Arts, Bachelor of Science (Education)*
Began Professional Career: *1952*
Books Illustrated: *No Known Survivors (Gambit, 1969); Pens and Needles (Gambit, 1975); The Arts of David Levine (Alfred Knopf, 1978)*

Undoubtedly one of the most important caricaturists of the twentieth century, David Levine's uncommon work appears regularly in the *New York Times Review of Books* and has been published in *Time, Newsweek, Life, Esquire* and *Vogue*. For the aspiring caricaturist, Levine advises that he "study the tradition of great draftsmanship and draw!!!"

On LBJ and Nixon:

"Their noses, from my point of view, enable the audience to deal with them not as Lords, but as ordinary-sized human beings. This is the purpose of the exaggeration of the political caricature in that case—to bring down the scale of this human so that you really see him as making possible error-filled decisions."

On Drawing in Pencil:

"First I sketch my caricatures in pencil, but I don't crosshatch with it—I just smear it around to establish the caricature. Therefore, when the time comes to ink in the drawing, I play with the pen to be creative and constructive. Without that, it would be terribly boring to just repeat everything."

On Drawing in Pen:

"On the other hand, when I'm finished with the pen and ink, the drawing is flat and not nearly as full of the touch that is achieved with a nice, rich, soft pencil. The best [pencil] drawing has been destroyed by having to render it in ink for reproduction purposes."

RICK MEYEROWITZ

Born: *November 29, 1943*
Birthplace: *New York, NY*
College: *Boston University*
Degree: *Bachelor of Fine Arts (Painting)*
Began Professional Career: *1967*
Books Illustrated: *Nosemasks (Vol. 1 & 2)* (Workman Publishing); *Dodosaurs: The Dinosaurs That Didn't Make It* (Harmony Books); *Paul Bunyan* (Picture Book Studio, 1990)

When you see them, you're instantly able to identify these stylish caricatures as Rick Meyerowitz's. Describing himself as National Lampoon's "premiere artist for nineteen of their twenty years," Meyerowitz has written and illustrated about 150 articles for the iconoclastic humor magazine.

On National Lampoon:

"I quit doing stuff for the magazine because over the last few years there was a lack of critically good stuff. As the magazine went into an intellectual hole, even though I was doing my best stuff, nobody was reading it."

On Plagiarists:

"I'm not really bothered by [cartoonists] who mimic me, because I know they can't really draw like me anyway. But it does bother me when the mimickers do a poor job and everyone thinks it's Meyerowitz going downhill."

On Education:

"In recent years, when I've spoken to groups of art students, I've stressed the need for a fully rounded education. I believe it is a prime ingredient in the development of an artist. There are many talented people in art schools who'll never recognize their ambitions because of their lack of ideas."

BILL PLYMPTON

Born: *April 30, 1946*
Birthplace: *Portland, OR*
College: *Portland State University*
Degree: *Liberal Arts degree in graphic design*
Began Professional Career: *1966*
Books Illustrated: *Tube Strips* (Smyrna Press, 1977); *Medium Rare* (Holt, Rinehart & Winston, 1978)

These days, Bill Plympton draws the same thing over, and over, and over again. It's not that he's having a difficult time correctly caricaturing a subject, it's that Plympton's current obsession is animation. In 1987, Plympton's animated short, *Your Face*, was nominated for an Academy Award. Before switching to animation, Plympton's weekly editorial cartoons and caricatures were syndicated by Universal Press Syndicate.

On Influences:

"Like most caricaturists, I find that the best pen-and-ink drawers were around the turn of the century — people like Charles Dana Gibson, Windsor McKay, Sir John Tenniel, Thomas Nast, A.B. Frost. My favorite is Frost, who is perhaps best known for illustrating the Uncle Remus fairy tales."

On Caricaturing Ronald Reagan:

"Reagan was a little more difficult to caricature than Nixon. He was a fairly handsome man, but fairly stupid and lazy — not too bright of a president. His eyes were always closed, his forehead was fairly small, which made him look ignorant."

On Losing Perspective:

"Once you start caricaturing a subject over and over again, you lose all perception of perspective. You're not sure what's real anymore. I'll then put the caricature up to a mirror and it will look like a whole new face — you see things you didn't see before."

ROBERT RISKO

Born: *November 11, 1956*
Birthplace: *Ellwood City, PA*
College: *Kent State University, Ohio*
Major: *Fine Arts/Painting*
Began Professional Career: *1974*
Books: *Fame* (Harmony, 1979) and *Fame II* (Harmony, 1981)

Known for his retro airbrush style, Robert Risko's caricatures have appeared in such magazines as *Time*, *Rolling Stone*, *Playboy*, *Vanity Fair*, *Esquire* and *Interview*. For the aspiring caricaturist, Risko advises that he "take lots of Vitamin C."

On Facades:

"What makes me different from Hirschfeld or a lot of other caricaturists is that when I caricature, I give my own personal view of the subject. I am more or less trying to expose the person behind the facade. Whatever format my caricature takes, the one thread of continuity is that it is personal. My success has been that a lot of people have seen the same vision that I have. I am conscious of the way that media has promoted people to the point that I am asked to do the caricature of them."

On Capturing Likeness:

"I do many sketches, all from different angles, using videotape to see the way the person is animated. When I first started out, I was groping more into thin air trying to find the various levels of a person's likeness. Now I have a hold on it—it doesn't take me quite as long to caricature someone. I go for the shapes and lines that most recognizably make up that person's face."

On Time:

"My rough drawings can take anywhere from one day to one week. It depends on how good the reference is, how much I like the subject, how much I am into the drawing, how much I know that personality, how much I really want to get into exploring the other possibilities rather than just the first thing that comes to mind. The average time is three to four days for the sketches. During that time I'm not totally working on the caricature—I take breaks and come back to analyze it."

GERALD SCARFE

Born: *June 1, 1936*
Birthplace: *London, England*
College: *Scarfe's schooling was "very erratic" due to chronic asthma*
Began Professional Career: *1956*
Books Illustrated: *Gerald Scarfe* (Thames & Hudson, 1982); *Scarfe by Scarfe* (Hamish Hamilton, 1986); *Scarfeland* (Hamish Hamilton, 1989)

An extremely versatile artist, Scarfe's drawn, painted and sculptured caricatures have appeared in *Time*, *Esquire* and *Punch*. Perhaps his most famous animation sequences are those which appear in the Pink Floyd film, *The Wall*.

On Film Versus Print:

"I do like the solitude of my studio as an antidote to the compromises one has to make as a film director, because with film, you never get exactly what you want. As an artist you think of something and, if all is well, it should travel down your arm and out through your pen or brush onto the paper or canvas. When you are working on films, by the time you've translated the idea to several people, it's quite a different idea than what you originally had."

On Nixon:

"*Time* sent me to cover Nixon's Presidential Campaign in 1972. Nixon didn't want me to go. One of his aides must have found out the type of work I did."

On Caricaturing George Bush:

"If I am caricaturing a new personality like Bush, I would use photographs, watch him on TV and start drawing. At first, these drawings might be very adventurous—they would be for myself. Bit by bit I can "push" the caricature. I can make his face elongated, make his forehead a bit bony, distort his nose and bowed upper lip and his teeth—bit by bit I can exaggerate those features. That's where the fun comes in for me."

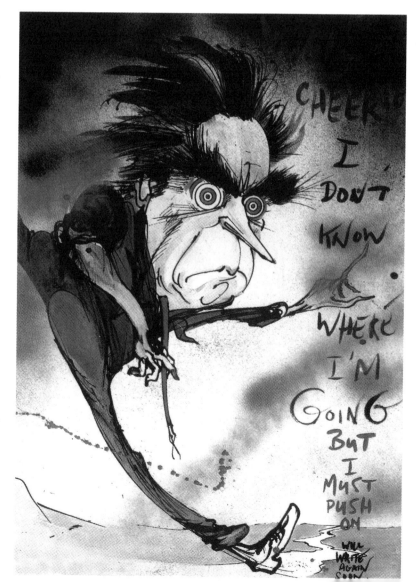

EDWARD SOREL

Born: *March 26, 1929*
Birthplace: *New York, NY*
College: *Cooper Union*
Degree: *Bachelor of Arts in Commercial Art*
Began Professional Career: *1960*
Books Illustrated: *Moon Missing* (Simon and Schuster, 1963); *Making the World Safe for Democracy* (Swallow Press, 1972); *Superpen* (Random House, 1978)

Known for his uncommon pen-and-ink style, Edward Sorel's cartoons and caricatures have appeared in such magazines as *Time*, *Esquire*, *Atlantic*, *GQ* and *The Nation*. Sorel's tongue-in-cheek advice to the aspiring caricaturist is that he should "marry someone with a good job."

On David Levine:

"David Levine just really knows how to draw. Levine is able to do a convincing drawing without reference material, maybe because his understanding of drawing is more solid than mine."

On His Style:

"When I was at Cooper Union, abstract expressionism was 'in,' and good drawing was out. The schools then didn't teach you how to draw, and I didn't want to become a painter. I was over forty years old before I did what I considered to be a caricature in 'my' style. I wish I could have learned how to draw in school. But because I didn't, I feel that will be a handicap all of my life."

On Hard Work:

"I worked hard to be good as an artist. I feel my talent just has come from hard work. It doesn't come easy for me, and I am better at it than most because I worry about it more than most. I don't do anything else but my work."

BRUCE STARK

Born: *February 17, 1933*
Birthplace: *New York, NY*
College: *School of Visual Arts*
Major: *Illustration*
Began Professional Career: *1960*

Part caricature, part portraiture, Bruce Stark's jocular work has appeared in TV *Guide*, *Time*, *Fortune*, *Forbes* and *Reader's Digest*. Stark prefers calling himself an "illustrative cartoonist," saying that he tries to get "a Norman Rockwell kind of look to the facial caricatures while exaggerating the expressions a little bit."

On Penciling:

"I like to find out all my mistakes in the penciling stage, and I do pencil very much. A lot of my pencil drawings are better than the final, inked caricature. Nevertheless, I probably spend too much time on the penciling because I like doing it more than anything else. Unfortunately, it's something that the public never sees."

On Improving Your Skills:

"I think if you keep caricaturing and working at it, you're going to get better. If you're inquisitive and excited about your work, you're always going to get better. Whether you get better by absorbing all that's around you, or from what people tell you, I think it's about fifty-fifty."

On Caricature's Purpose:

"I don't try to provoke, demean or make fun of anybody with my caricatures. I always try to project some kind of enjoyment for the person who looks at the caricature and for the person whom I am caricaturing. I'm a lot different from these poison-pen guys who draw extra-large, big noses."

RALPH STEADMAN

Born: *May 15, 1936*
Birthplace: *Wallasey, Cheshire, England*
College: *East Ham Technical College,
London College of Printing and
Graphic Arts*
Major: *Life Drawing/Graphic Arts/
Typography*
Began Professional Career: *1956*
Books Illustrated: *Alice in Wonderland*
(Dobson, 1967); *Fear and Loathing on
the Campaign Trail* (Allison and Busby,
1975); *America* (Straight Arrow Press,
1974; paperback reprint by
Fantagraphics Books, 1989); *Star
Strangled Banger* (Harrap, 1987)

Steadman's chaotic cartoons and
caricatures have appeared in such
American publications as *Rolling
Stone*, *Esquire*, and the *New York Times*.
There are plans to turn his book,
God the Big I Am, into a play, and
Steadman would like to cast Allen
Ginsburg or Bill Murray in the part
of God. "And I think God should talk
in George Harrison's voice," says
Steadman.

On Picasso:

"I believe Picasso to be the great
cartoonist of the twentieth century
because he gave us the vocabulary.
He showed us how to use a line in so
many different ways. A line is either
dead or alive. In some ways, Picasso
spoiled it for others because he was
so good."

On American Caricaturists:

"There are a lot of American carica-
turists that I don't rate as very inter-
esting people because they don't
seem to be able to draw from the
start."

On Market Forces:

"I simply [caricatured] what I
wanted, irrespective of these
strange market forces that some
people bow to. That's what the
problem is with a lot of [caricatur-
ists]. They bow to market forces
first. They allow that to dictate how
they express themselves."

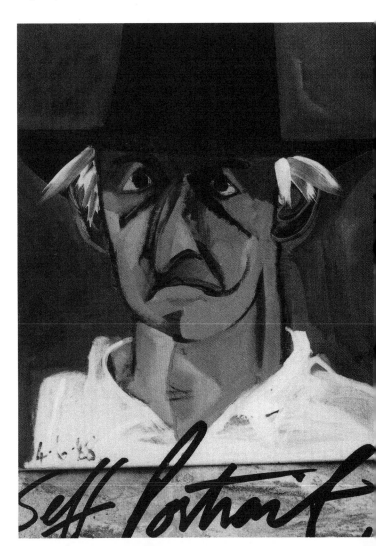

BILL UTTERBACK

Born: *January 5, 1931*
Birthplace: *Arlington Heights, IL*
College: *Art Center, Los Angeles*
Degree: *Bachelor of Professional Art*
Began Professional Career: *1966*

There's a reason you don't see too much of Bill Utterback. While an excellent caricaturist, Utterback never really promoted himself. Nevertheless, each year Utterback (a former employee in *Playboy*'s art department) is assigned the juicy task of caricaturing two dozen or more celebrities for *Playboy*'s "That Was The Year That Was" feature. Utterback has also done work for Chicago's renowned Second City Theater for the past twelve years.

On Caricature Talent:

"Basically, I think caricature is a talent that you are born with, and everybody has a different degree of that talent. Everybody can be helped to develop whatever talent they have, but somebody who can't draw very well will never become a good caricaturist or a good draftsman. They can improve slightly, but that's it. You have to be born with it."

On Portraiture:

"One evident thing about my stuff is that I am basically a portrait painter, and I come to caricature not so much as a cartoonist. I have always loved likenesses in general, and I like to think that I have a sense of humor."

On His Lack of Promotion:

"I have never promoted myself. I have walked the streets maybe a week and a half in my entire life. Usually, the phone rings and somebody has a job and I'll take it. A lot of times maybe I should have passed it up because it didn't pay that much, or it was a local thing. Maybe I should have gone after some of the bigger stuff. Maybe I lacked confidence."

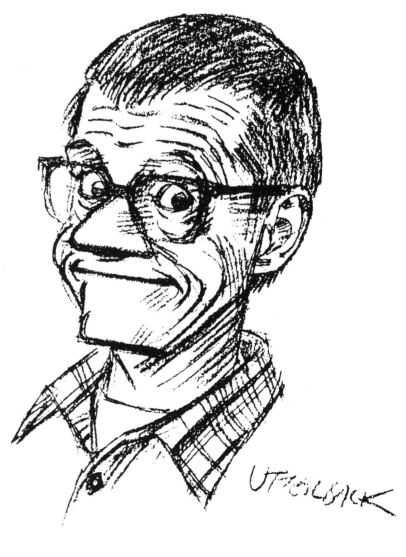

SAM VIVIANO

Born: *March 13, 1953*
Birthplace: *Detroit, MI*
College: *University of Michigan at Ann Arbor*
Degree: *Bachelor of Fine Arts (Art)*
Began Professional Career: *1976*

A new member of MAD's "usual gang of idiots," Sam Viviano's caricatures have also appeared in *Rolling Stone*, *Family Weekly*, *Reader's Digest* and *Consumer Reports*. Viviano also does quite a bit of work for corporate and advertising clients. His advice to the aspiring caricaturist is simple: "Love it, or don't do it—it ain't worth the aggravation."

On Crowds:

"I unfortunately have gotten a reputation as someone who can do crowd [caricature] scenes. I do covers for the magazine *Institutional Investor* twice a year. They need a caricaturist who can give them thirty-six to sixty-five caricatures. The fastest I've been able to work for them is sixty caricatures in nine days."

On Huge Jaws:

"I give my people these huge jaws. I'm not just drawing what I see from a front view, I'm incorporating a side view as well. I distort what I see in my head."

On Caricature's Role:

"I don't think caricaturists can be out to change the world with a pen rather than a sword. It's not that bold and big. All art has some way of modifying the way that we see the rest of the world."

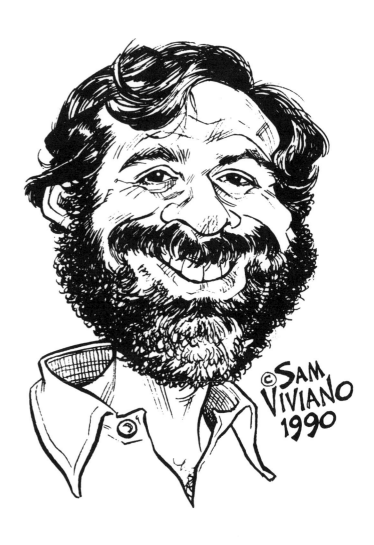

MICHAEL WITTE

Born: *February 7, 1944*
Birthplace: *St. Louis, MO*
College: *Princeton University*
Degree: *English Literature*
Began Professional Career: *1968*
Books Illustrated: *Scroogie #1* and *#2*
 (New American Library, 1976, 1977);
 The Book of Terns (Penguin, 1978);
 Claus (Holt, Rinehart & Winston, 1982)

These days, Michael Witte's work is popping up everywhere — from *Time* to the *New Yorker*, *Fortune* to *Esquire*, *People* to SPY. The question isn't who has Witte drawn for, it's who *hasn't* he drawn for. As adept with color as he is with ink, Witte's caricatures exude a sophisticated ambience and stylish flair. Witte's sage advice to the aspiring caricaturist is, "Draw. Eat. Draw. Sleep. Draw. Love. Draw. Procreate. Draw. Be happy!"

On Drawing from Life:

"When caricaturing, I never work off of videotape. Recently, I have been doing caricatures for the front of the book section of the *New Yorker*, which in effect is what Hirschfeld has been doing all these years. I have attended the theater productions and try to sketch in the theater. It's difficult, but also much preferable to working from photographs because you get a real sense of what your subjects look like."

On Tools:

"At this point of my career, I'm still experimenting with drawing tools, trying to arrive at something I feel comfortable with. Recently, I have been using a brush effect — a Winsor & Newton No. 1 or No. 2. My standard tool for the past fifteen years has been a simple 102 crow quill pen nib. I just haven't found anything to surpass that."

On Working Fast:

"I can't do my work automatically yet. But I do work fast by necessity to keep ahead of the creditor!"

PERMISSIONS

Dave Arkle. *McMahon and Clark*, pg. 68. ©1989 by Dave Arkle Illustration.

Jim Borgman. *Rolling Stones*, p. 15; *Presidents*, p. 24. Reprinted with special permission of King Features Syndicate, Inc.

Andre Bergier. *Three party portraits*, p 43. Use with permission of the artist.

Steve Brodner. *Jim Bakker*, p. 12; *LBJ*, p. 14; *Jesse Jackson*, pg. 19; *Reagan*, p. 29; *Mailer*, p. 58; *Mailer and Vidal*, p. 81. Used with permission of the artist.

Philip Burke. *Malcolm Forbes*, p. 17; *David Byrne*, p. 44; *Elvis Costello*, p. 48; *Rob Lowe*, p. 57; *John Lovitz*, p. 75; *Deborah Norville*, p. 82; *Paula Abdul*, p. 93. ©1990 Philip Burke.

Garry W. Colby. *Stallone*, p. 69. ©Garry W. Colby.

William Cone. *Johnny Carson*, p. 9; *Vanna and Pat*, p. 68. Permission to reprint by the *San Francisco Chronicle*.

Paul Francis Conrad. *Esquire Caricatures*, p. 67. Used with permission of the artist.

Miguel Covarrubias. *Douglas Fairbanks, Jr.*, p. 55.

Rudy Cristiano. *Dionne Warwick*, p. iv; *Jackie Gleason*, p. 22; *Rodney Dangerfield*, p. 62; *Bill Cosby*, p. 91; *Barry Manilow*, p. 110. Used with permission of the artist.

Jack Davis. *Oprah and Phil*, p. 28; *Gone with the Wind*, p. 96. Used with permission of the artist.

Jack Dickason. *Reagan*, p. 50. Used with permission.

E.C. Publications. *thirtysomething*, p. 20; *Ghostbusters*, p. 27; *Six figures*, p. 52; *Mulligan*, p. 94

Al Evciman. *Star Mailer*, p. 110. Used with permission of the artist.

Gerry Gersten. *David Letterman*, p. 9; *Sid Caesar*, p. 30; *Reagan*, p. 51; *Woody Allen*, p. 69; *Madonna*, p. 82; *Arsenio Hall*, p. 82. Used with permission of the artist.

Robert Grossman. *Jerry Lewis*, p. 11; *Geraldine Ferraro*, p. 13; *Carl Icahn*, p. 37; *Presidential Candidates*, p. 45; *Reagan*, p. 51; *Elvis*, p. 75; *Candidates*, p. 90; *Praying Candidates*, p. 90. ©1990 Robert Grossman.

Steve Haefele. *Jerry Lee Lewis and Bride*, p. 110. ©Steve Haefele.

Al Hirschfeld. *Lucy and Desi*, p. iii; *Odd Couple*, p. v; *Hope*, p. 11; *Fonda*, p. 31; *Cousteau*, p. 55; *Esquire Caricatures*, p. 65; *Two Elvises*, p. 87; *Cronkite*, p, 92. Copyright ©Al Hirschfeld. Drawing reproduced by special arrangement with Hirschfeld's exclusive representative, The Margo Feiden Galleries Ltd., New York.

Ori Hofmekler. *Last Supper with Jesse Jackson*, p. 4; *Madonna and Penn*, p. 86; *California Reagans*, p. 109. Used with permission of the artist.

Kevin Kallaugher. *Self-promo mailer*, p. 3. Used with permission of the artist.

Karl Hubenthal. *Former World Powers*, p. 23; *Sammy Davis*, p. 36; *Reagan*, p. 51; *Nixon*, p. 80. Printed with permission of the artist.

Taylor Jones. *Bush and Dukakis*, p. 26; *Bruce Springsteen*, p. 19; *Reagan*, p. 50; *Jesse Jackson*, p. 59; *Prince Charles*, p. 60; *Dan Quayle*, p. 72; *Donald Trump*, p. 77; *Roseanne Barr*, p. 88. ©Los Angeles Times Syndicate. Reprinted by permission.

David Levine. *Nixon*, p. 2; *Kennedy*, p. 16; *Elvis*, p. 18; *Ford*, p. 49; *Dayan*, p. 50; *Esquire Caricatures*, p. 66; *Nixon*, p. 70; *Hemingway*, p. 98. Used with permission of the artist.

Ranan Lurie. *Dan Quayle*, p. 34; *Reagan*, p. 50; *Spock*, p. 62. Used with permission of the artist.

Mark Marek. *The Beatles*, p. 20. ©Mark Marek, 33.

Patrick McDonnell. *Let's Party*, p. 34. ©1987 by Patrick McDonnell. Used with permission of the artist.

Jack McLeod. *Reagan*, p. 51; *Weinberger*, p. 98. ©Times Journal Co.

Jimmy Margulies. *Tammy Faye*, p. 8; *Whoopi Goldberg*, p. 83. Used with permission of the artist.

Rick Meyerowitz. *Reagan at Bitburg*, p. 52; *Carson and McMahon*, p. 108. ©Rick Meyerowitz.

Sam Norkin. *Party Sketches*, pp. 40-41; *Satchel Paige*, p. 46; *Reggie Jackson*, p. 63; *Dustin Hoffman*, p. 73; *Ted Kennedy*, p. 78; *Gilda Radner*, p. 83; *Katherine Hepburn*, p. 94; *George Schultz*, p. 101. ©1990 Sam Norkin.

Kate Salley Palmer. *Reagan*, p. 51; *Jim and Tammy*, p. 53; *Jimmy Carter*, p. 90; *Life Sketches*, pp. 106, 107. ©Kate Salley Palmer.

Mike Peters. *Nixon and Ford*, p. 24; *Marx*, p. 33. Used with permission of the artist.

Bill Plympton. *Pete Rose*, p. 9; *Howard Baker*, p. 18; *JFK*, p. 57; *Ted Koppel*, p. 72; *Six Movie Stars*, p. 79; *Dolly Parton*, p. 84; *Gilda Radner*, p. 85; *Bob Dole*, p. 86; *Cosby*, p. 99. ©Bill Plympton.

Michael P. Ramirez. *Reagan*, p. 50; *Qaddafi*, p. 76; *Aquino*, p. 76. Reprinted with permission of Michael P. Ramirez and Copley News Service.

Robert Risko. *Lucille Ball*, p. 8; *Martin and Tomlin*, p. 10; *Stevie Wonder*, p. 47; *Reagan*, p. 50; *Johnny Carson*, p. 56; *Dolly Parton*, p. 84; *Johnny Mathis*, p. 89; *Bill Cosby*, p. 91. ©Robert Risko.

Gerald Scarfe. *Nixon*, p. 7; *Kennedy*, p. 25; *Thatcher*, p. 61; *Nixon as Airplane*, p. 76; *Sketch of Presidents*, p. 101. Used with permission of the artist.

Bill Schorr. *Robin Leach*, p. 103. Used with permission.

Bob Selby. *Don Zimmer*, p. 45. ©1985 Providence Journal.

Edward Sorel. *Dreck*, p. 21; *Dinosaurs*, p. 53; *Reagan*, p. 50; *Harry and Dick*, p. 58; *Woody Allen*, p. 69.

Spitting Image Productions. *Thatcher, Reagan and Castro*, p. 38. ©Spitting Image Productions Ltd.

B I B L I O G R A P H Y

Marcia Staimer. *Madonna and Warren Beatty*, p. 32; *Barbara Walters*, p. 85; *Oprah Winfrey*, p. 85; *Charles Manson*, p. 108. ©1989, '90 USA Today. All rights reserved.

Bruce Stark. *Love Boat TV Guide Cover*, p. 31; *Yogi Berra*, p. 44. Used with permission of the artist.

Ralph Steadman. *Reagan and Liberty*, p. 5. Used with permission. Published in the *New York Times*, 1975; *Reagan on Rope*, p. 5. Used with permission. Published in the *New Statesman*, 1979; *Godzilla*, p. 7. Used with permission. Published in *Rolling Stone*, 1973; *Dennis Conner*, p. 13. Used with permission. Published in *The Scar-Strangled Banger*, 1984; *Kissinger*, p. 61. Used with permission. Published in *Rolling Stone*, 1974.

Paul Szep. *Ted Kennedy*, p. 78. Used with permission.

Michael Thompson. *Reagan*, p. 50. ©Michael Thompson.

Rick Tulka. *Donald Trump*, p. 77. ©1989 Rick Tulka; *Spike Lee*, p. 91. ©1989 Rick Tulka; *Phil Donahue*, p. 91. ©1985 Rick Tulka; *Subway Faces*, p. 102. ©Rick Tulka; *Warhol*, p. 111. ©Rick Tulka.

Will Vinton. *FDR as The Great Cognito*, p. 38. ©Will Vinton Productions, Inc. All rights reserved.

Sam Viviano. *The Bushes and Reagans*, p. 39; *Billy Idol, Elvis Costello, Bob Dylan*, p. 95; *Joan Rivers*, p. 108; *TV Stars*, p. 111. Used with permission of the artist.

Pete Wagner. *Bud Melman*, p. 81. ©Pete Wagner, Minneapolis.

Bill Utterback. *Thatcher et al*, p. 44. ©William D. Utterback. All rights reserved. Reproduction in whole or in part without permission is prohibited.

Michael Witte. *Joe DiMaggio*, p. 1; *Chuck Berry*, p. 89. Used with permission.

Bob Zschiesche. *J. Edgar Hoover*, p. 74. ©1990 Bob Zschiesche.

Drucker, Mort. *Familiar Faces*. Ithaca: Stabur Press, 1989.

Funke, Phyllis Ellen. *Hirschfeld: Drawing from Life. Los Angeles Times*, Sunday Calendar Section, July 26, 1981.

Hamill, Pete. *Robert Grossman. Graphis*, October, 1977.

Harrison, Hank. *The Art of Jack Davis*. Redford: Stabur Press, 1987.

Hirschfeld, Al. *The World of Hirschfeld*. New York: Henry Abrams, 1968.

Levine, David. *No Known Survivors*. Boston: Gambit, 1970.

Levine, David. *The Arts of David Levine*. New York: Alfred A. Knopf, 1978.

Levine, David. *Portfolio of Caricatures and Watercolor Paintings. Communication Arts*, 1975.

Lucie-Smith, Edward. *The Art of Caricature*. Ithaca: Cornell University Press, 1981.

Meglin, Nick. *The Art of Humorous Illustration*. New York: Watson-Guptill, 1977.

Reilly, Jr., Bernard F. *Miguel Covarrubias Caricatures*. Washington, D.C.: Smithsonian Institution Press, 1985.

Sorel, Edward. *Superpen: The Cartoons and Caricatures of Edward Sorel*. New York: Random House, 1978.

Staake, Bob. *Humor and Cartoon Markets*. Cincinnati: Writer's Digest Books, 1990.

Steadman, Ralph. *Wrapping Wonderland*. HOW, January 1989.

Steadman, Ralph. *Scar Strangled Banger*. London: Harrap Limited, 1987.

The following interviews were conducted by Bob Staake for *The Complete Book of Caricature* (the dates of the interviews are noted):

Andre Bergier, May 1990

Steve Brodner, March 26, 1990

Philip Burke, March 30, 1990

Jack Davis, April 19, 1990

Gerry Gersten, March 29, 1990

Milton Glazer, April 30, 1990

Robert Grossman, March 19, 1990

Steven Heller, April 30, 1990

Taylor Jones, April 9, 1990

David Levine, March 19, 1990

Rick Meyerowitz, March 27, 1990

Sam Norkin, April 1990

Mike Peters, May 1990

Bill Plympton, March 29, 1990

Robert Risko, March 29, 1990

Gerald Scarfe, March 24, 1990

Bruce Starke, May 22, 1990

Ralph Steadman, March 30, 1990

Bill Utterback, April 30, 1990

Sam Viviano, March 29, 1990

Michael Witte, March 30, 1990

I N D E X